The Life Cycles of Butterflies

The
Life Cycles

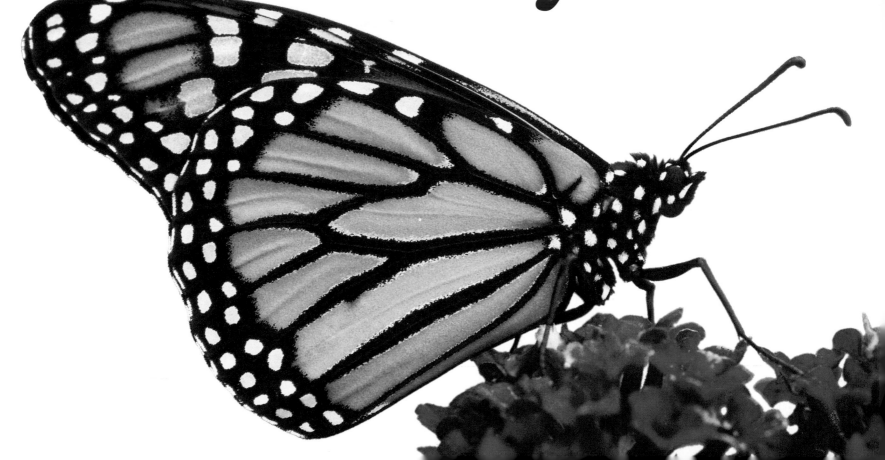

of Butterflies

From Egg to Maturity, a Visual Guide to 23 Common Garden Butterflies

By Judy Burris and Wayne Richards

Photography by Judy Burris, Wayne Richards, and Christina Richards

 Storey Publishing

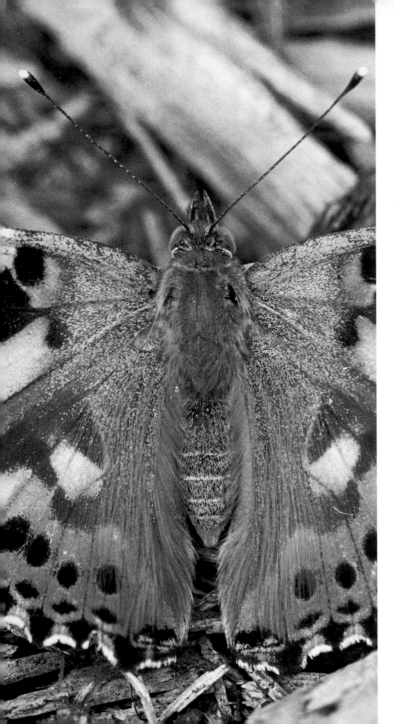

The mission of Storey Publishing is to serve our customers by publishing practical information that encourages personal independence in harmony with the environment.

Edited by Claire Mowbray Golding, Deborah Balmuth, and Sarah Guare
Art direction by Kent Lew and Cynthia McFarland
Cover design by Kent Lew
Text design and production by Jen Rork Design
Production assistance by Jennie Jepson Smith
Cover photographs by Judy Burris
Interior photographs by Judy Burris, Wayne Richards, and Christina Richards, except for those by:
© Henry W. Art 71 bottom row left; © Dale Clark 80 left, 108 right, 146 third row, second from right, 147 fourth row right; © Jeff M. Fengler 68 left, 108 left, 146 third row, second from left and fourth row, right; © MACORE, Inc. 79 bottom row second from left; © Paul A. Opler 108 center; Giles Prett 103 bottom row, second from left
Indexed by Christine R. Lindemer, Boston Road Communications

Printed in China by Toppan Leefung Printing Ltd.
10 9 8 7 6 5

LIBRARY OF CONGRESS CATALOGING-IN-PUBLICATION DATA

Burris, Judy, 1967–
 The life cycles of butterflies / by Judy Burris and Wayne Richards ; photography by
 Judy Burris, Wayne Richards, and Christina Richards.
 p. cm.
 Includes bibliographical references and index.
 ISBN 978-1-58017-617-0 (pbk. : alk. paper)
 ISBN 978-1-58017-618-7 (hardcover : alk. paper)
 1. Butterflies—Life cycles. I. Richards, Wayne, 1970– II. Title.
QL542.B87 2006
595.78'9—dc22 2005033532

Contents

Preface vi

1 The Butterfly from Start to Finish 1
How a Butterfly Lays Its Eggs • How a Caterpillar Grows •
How a Chrysalis Is Formed • Continuing the Cycle

2 Butterfly Life Cycles 19
Eastern Black Swallowtail • Giant Swallowtail • Pipevine Swallowtail • Spice-
bush Swallowtail • Tiger Swallowtail • Zebra Swallowtail • Gulf Fritillary
• Variegated Fritillary • Zebra Longwing • Question Mark • Eastern
Comma • Common Buckeye • American Lady • Painted Lady • Red Admiral
• Silvery Checkerspot • Red-spotted Purple • Viceroy • Monarch • Queen •
Cabbage White • Clouded Sulphur • Pearl Crescent

3 Butterfly Habitat Gardening 113
Host Plants • Our Top Nectar Flowers

4 Other Garden Visitors 135
Assorted Butterflies • Assorted Skippers

Glossary 143
References 145
Easy Comparison Guides: Eggs, Caterpillars, Chrysalises 146
Acknowledgments 149
Index 150

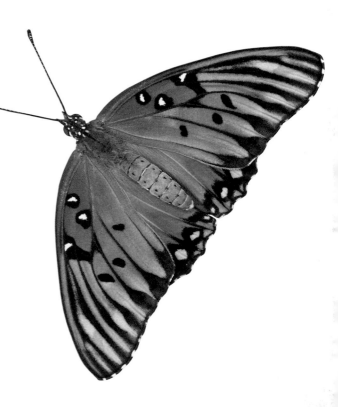

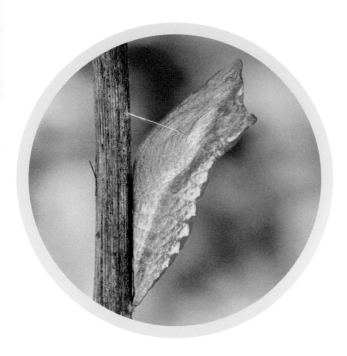

▲ Eastern Black Swallowtail chrysalis.

Preface

When we were growing up we spent many weekend mornings with our mother on hiking trails. Her love of trees, flowers, and critters was definitely contagious. We would roll out of bed at the crack of dawn so we could be the first ones to the park and have the trails all to ourselves. We would often compete with each other to see who could identify the most trees and flowers and spot a box turtle or a chipmunk.

Our interest in insects began when we discovered dead butterflies on the grilles of trucks in parking lots. Many times their wings were in very good condition, flattened against the radiator. We would carefully peel them off and take them home to add to our collection. After several years we had examples of nearly every kind of butterfly that was common to our part of the country. We still have these specimens pressed in frames to remind us of our first sparks of childhood interest.

After we grew up and became homeowners close to each other in Kentucky, we both decided to fill our yards with flowers. At first we gardened with no real plan or purpose in mind. We each learned the hard way that some plants are very invasive and others are too finicky to grow in our Kentucky clay. So, after much trial and error — and endless trips to nurseries — we decided to garden strictly for the butterflies we loved. Our backyards are now overflowing with every kind of caterpillar host plant and nectar-producing flower we can get our bug-loving hands on. We compete to see who can grow the widest variety of host plants and nectar flowers and take the best photographs of visiting butterflies.

We've used as many of those pictures as possible in this book, not only for your enjoyment, but also to help you identify a specific butterfly during any stage of its development. We took most of them in our own backyards; the others were taken at local parks.

When we first started to entice butterflies to our flower gardens, we relied heavily on resources that listed specific host plants and nectar flowers. We weren't experienced enough to know what these plants actually looked like just from reading their names, which were often in Latin. Because we remember our early frustrations, our book provides actual pictures of the host and nectar plants that we've used successfully in our own gardens.

Every day is a new adventure for us: checking plants for eggs and caterpillars, sneaking up on butterflies to photograph them, and excitedly phoning each other when we spot a new species visiting our yards. As you use this book, we hope our enthusiasm rubs off on you. We're sure that once you experience the joy and wonders of the butterfly world, you'll be hooked just as we were so many years ago.

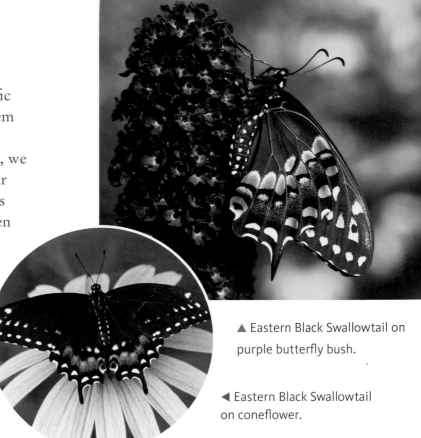

▲ Eastern Black Swallowtail on purple butterfly bush.

◄ Eastern Black Swallowtail on coneflower.

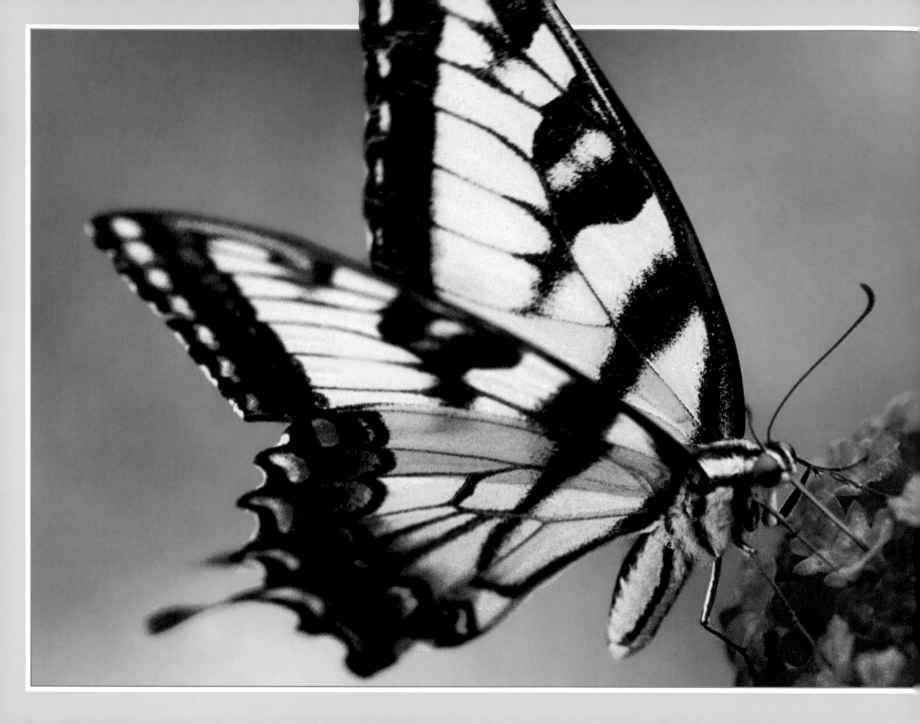

The Butterfly from Start to Finish

THERE'S SOMETHING VERY SPECIAL ABOUT BUTTERFLIES. Maybe it's their gentle nature, striking colors, or graceful flight. Butterflies have symbolic meaning in many cultures, and they've inspired artists and poets over the centuries. They've been written into fairy tales, woven into tapestries, and painted on pottery. Butterflies touch the hearts of young and old alike. And if one actually lands on you, somehow you feel honored, as if you were singled out as an especially trustworthy companion.

◄ Gulf Fritillary egg on a vine tendril.

UCH OF THE ALLURE of butterflies lies in the fact that they're complicated creatures. Like ladybugs, ants, bees, and fleas, they undergo what is called *complete metamorphosis.* This means that they start out in one form and change into a completely different creature by the time they are fully developed.

We can't think of many things that are as amazing as the life cycle of the butterfly. To progress from egg, to caterpillar, to chrysalis, to gorgeous winged creature, all in the course of a few weeks, is a rare and wonderful achievement. Here's how it works.

How a Butterfly Lays Its Eggs

Most female butterflies are able to mate as soon as they emerge from their chrysalis. Some males need a day or two before they are ready. On rare occasions, certain species of male butterflies will search for a female that is still inside her chrysalis, almost ready to emerge. The male peels open a small part of the chrysalis, mates with the female, and leaves behind some of his *pheromone,* a chemical substance that lets other males know that this female is already mated. But most butterflies find their mates during the course of the day as they fly around gardens, fields, parks, and wooded areas searching for sweet things to eat.

The butterfly egg, or *ovum,* is covered by a strong, protective membrane called the *chorion.* Tiny pores covering the egg surface allow the caterpillar embryo to breathe inside the

egg. The egg may change color just before it is ready to hatch.

The egg usually hatches within a few days, depending on the weather and the time of year. The dark head of the caterpillar may be visible as it eats a hole in the egg so it can crawl out onto a leaf. Some caterpillars eat the rest of their eggshell before they start eating their host plant.

Butterflies have chemical receptors, something like our taste buds, on their feet, tongue, and antennae. They use them to smell the air, taste their food and their host plants, and pick up the scent of a mate. When a female is ready to lay eggs, she begins to search for appropriate host plants for the young caterpillars to eat. She finds these plants by sight and smell, landing on a plant of choice and scratching the leaf surface to "taste" it with her feet. Once she decides on a plant, she curves her abdomen downward to touch the plant surface and places an egg on a leaf, stem, flower, or seedpod. The butterfly's body produces a special substance that glues the egg in place so it won't wash off in the rain.

Butterflies lay their eggs in many different formations on a plant leaf: single eggs, groups of eggs, even eggs stacked on top of each another. Some are round and smooth like tiny pearls, while others look like barrels with ridges or dimpled golf balls. You're not likely to find these eggs by accident; it

▲ (TOP) Zebra Swallowtail egg on a pawpaw leaf.
(MIDDLE) Clouded Sulphur egg on a clover leaf.
(BOTTOM) Pipevine Swallowtail caterpillars eating their eggshells.

usually takes a sharp eye to spot them. They may be placed on the underside of leaves, at the tip of a leaf, or inside blooming flowers. Some eggs are also very, very small. The eggs shown in our photos have been greatly magnified.

Never try to remove an egg from a leaf: It's often glued on so strongly that the egg will tear apart rather than detach. If you want to take a closer look at an egg, look at it through a magnifying glass.

EGG SHAPES & TEXTURES

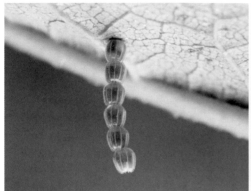

Question Mark eggs stacked on the underside of a hop vine leaf.

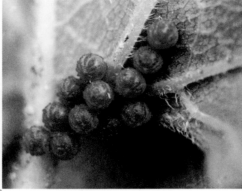

Pipevine Swallowtail eggs laid in a cluster on a pipevine leaf.

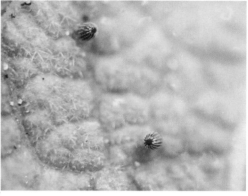

Painted Lady eggs on a hollyhock leaf.

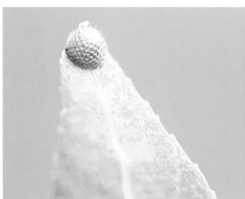

Viceroy egg on the tip of a willow leaf.

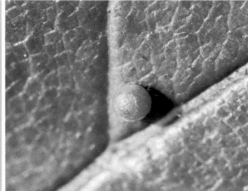

Giant Swallowtail egg on the upper surface of a prickly ash leaf.

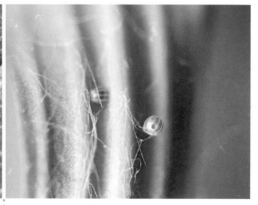

Common Buckeye eggs on the underside of a plantain leaf.

How a Caterpillar Grows

Butterflies spend the early part of their lives, the *larval* stage, as hungry caterpillars. They devour the leaves of their host plant so they can store up enough energy for their *metamorphosis,* the change from caterpillar to butterfly. For a couple of weeks on average, depending on the weather, they do nothing but eat. A caterpillar's rate of growth is controlled by such factors as heat, humidity, and the overall quality and quantity of the host plant's leaves. The caterpillar will grow faster if its host plant's leaves are young and tender, and therefore easy to chew and digest.

Of course, the more a caterpillar eats, the faster it will grow, but a caterpillar's skin can stretch only a small amount. Once it reaches its limit, stretch detectors in the joints between the body segments send signals to the brain to trigger the growth of a new, bigger skin underneath the old one. The old skin is no longer needed and must be shed. This process is called *molting.* Growth spurts between the molts are called *instars.* A caterpillar may molt up to five times, depending on its species, the weather conditions, and the availability of food. Caterpillars should never be disturbed during this process. They are extremely vulnerable to stress and injury, possibly fatal, at this stage.

There are several early indications that a caterpillar is ready to molt. It stops eating, it may sit very still for a long time, and it looks swollen, a bit like an overstuffed sausage.

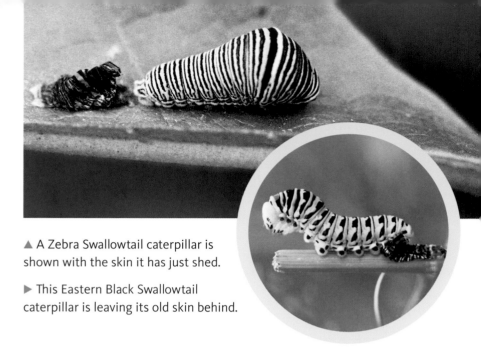

▲ A Zebra Swallowtail caterpillar is shown with the skin it has just shed.

▶ This Eastern Black Swallowtail caterpillar is leaving its old skin behind.

To shed its old skin, the caterpillar first spins a small patch of silk as an anchoring point on a leaf or stem. Then it turns around and holds on to the silk with its rear claspers. The old head capsule pops off first. Next the caterpillar wiggles out of the old dry skin to reveal a new loose, moist skin. Still damp and pliable, the new skin stretches as the caterpillar takes in air. Some caterpillars eat their old skin at the end of the molting process. They may change color or physical appearance with each successive molt.

The coloration of some caterpillars allows them to avoid hungry predators: The greens and browns blend in with the environment or resemble bird droppings. Other caterpillars are brightly colored, as if to warn potential predators against

eating them. For instance, the bright orange and black Monarch caterpillar absorbs toxins from milkweed plants, which can make *vertebrates* (animals with backbones), like birds, lizards, and mammals, very sick. These animals quickly learn to leave Monarch caterpillars alone. However, invertebrate predators like wasps and spiders are immune to these poisons and will happily eat Monarchs for lunch.

A caterpillar's markings can also help protect it. Some caterpillars have *false eyespots,* patterns on the skin that look like large eyeballs. If approached, the caterpillar may rear up on its hind legs, perhaps attempting to look like a snake.

Swallowtail caterpillars have a special defense organ called an *osmeterium.* This is an orange or red forked gland that is hidden under the skin behind the head. When the caterpillar feels threatened, it can shoot out the gland like a snake tongue and touch the predator with it. If the sudden whiplash movement doesn't spook the intruder, the foul-smelling substance that the gland secretes will offend even a human nose at close range.

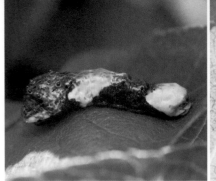
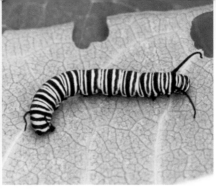

▲ Bird dropping or Giant Swallowtail caterpillar?

▲ The Monarch caterpillar is toxic to some predators.

Other caterpillars take a more passive approach: They curl up and drop to the ground if threatened. Once they feel safe enough, they return to the host plant.

Another tactic is the head-butt. If a caterpillar feels something brush against its skin, it may snap its head from side to side in an attempt to push away the intruder.

Most caterpillars are solitary eaters, but a few species dine together in groups. When they feel threatened, all the caterpillars may twitch at the same time, perhaps as a way to scare predators.

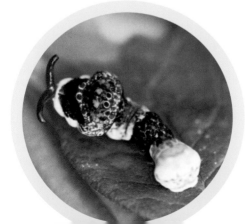

◀ (LEFT) This caterpillar is curled up and waiting for predators to leave. (MIDDLE) Sometimes looking like a snake is enough to deter a predator. (RIGHT) Swallowtail caterpillars have a bright orange or red gland, called the osmeterium, that they use to threaten attackers.

Black Swallowtail

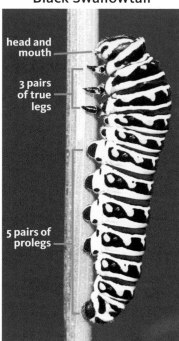

head and mouth

3 pairs of true legs

5 pairs of prolegs

Spicebush Swallowtail

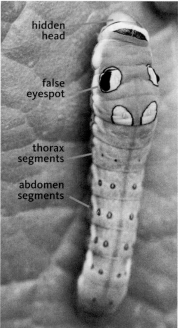

hidden head

false eyespot

thorax segments

abdomen segments

Cecropia moth

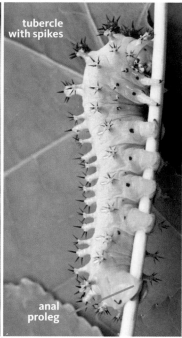

tubercle with spikes

anal proleg

Zebra Longwing

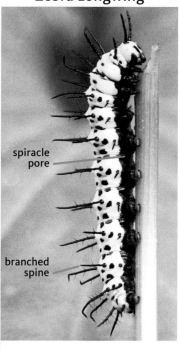

spiracle pore

branched spine

Caterpillars have several very tiny simple eyes that can detect light and movement. Their six true legs carry over to the adult butterfly stage. The prolegs are covered with tiny hair-like hooks for gripping.

Some caterpillars have large false eyespots that may fool predators into thinking they're more of a threat than they are. The larger front segment also protects the head from attack.

This caterpillar is covered in colorful knobs topped with black spikes. It looks scary but is actually harmless. Some moth caterpillars do have poisonous hairs and spines that can irritate your skin if you handle them.

Caterpillars take in air through small holes, called *spiracles,* on the sides of their body. Because these holes are so close to the ground, caterpillars can easily drown, even in a puddle.

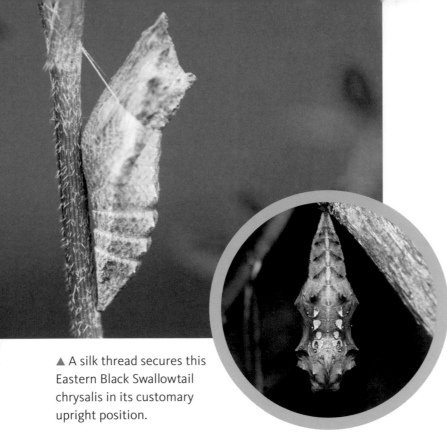

▲ A silk thread secures this Eastern Black Swallowtail chrysalis in its customary upright position.

▲ A Question Mark chrysalis blends into its brown surroundings.

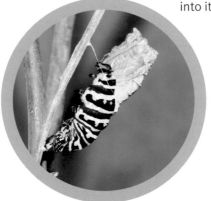

◄ A Black Swallowtail chrysalis sheds its caterpillar skin.

How a Chrysalis Is Formed

Once a caterpillar has reached maturity, it begins to look for a good place to *pupate,* or enter the chrysalis phase. It stops eating and may empty the undigested contents of its gut. Sometimes it changes color. Generally, the caterpillar leaves its host plant and wanders away to find a safe place from which to hang. All sorts of locations may be suitable: A pile of wood offers good protection; the underside of a large leaf provides shelter from rain; a tree branch is an easy place to blend in. Sometimes the caterpillar spends several hours crawling around to find the perfect spot.

After the caterpillar has chosen a place, it begins to spin a patch of silk that will be the anchoring point for the chrysalis. The caterpillar has a gland called a *spinneret* below its mouth that produces silk. By moving its head back and forth, the caterpillar can weave a mat out of silk threads. Using special clasping hooks on its rear end, the caterpillar then backs up and grabs the silk patch and holds on tight. In fact, its life may depend on the strength of its grip. If the soon-to-be chrysalis can't hang on through wind and rain, it will probably die when it hits the ground, bursting like a water balloon. If it survives the fall, a predator may eat it.

We've discovered chrysalises hanging as low as a few inches from the ground on a plant stem and as high as six feet up on the side of a building. And when you have a garden full of host plants, you're bound to find chrysalises

in some strange places. Last summer we found one hanging from the underside of a rocking chair on Wayne's deck. We couldn't let anyone sit in it until the butterfly emerged. We've found chrysalises hanging from deck rails and garden statues, as well as on sliding glass patio doors. We're now in the habit of checking everywhere for these surprise packages.

Just Hanging Around

After the caterpillar gets a good grip, it may hang upside down, as Monarchs do, or spin a silk thread and use it as a harness to support itself upright, as swallowtails do. Up to now, *juvenile hormone* has kept the insect in the caterpillar stage through each molt. Now that it is fully grown, production of this hormone has stopped, and the caterpillar sheds its skin for the last time, to reveal a chrysalis. The old skin splits first at the head, and the *pupa* wiggles and squirms its way out. When the skin has peeled all the way down to the rear end, the pupa must twitch violently to break the small ligament attached to the skin. Then the skin falls away like a stretched-out old sock.

Once the chrysalis dries and hardens a bit, it gains some protection from the weather and small predators. Its dull coloration, usually shades of green or brown, helps it blend in among leaves and twigs. If this phase of its life cycle occurs during the warm summer months, the butterfly should be fully developed and ready for *eclosion,* or emergence from

▲ This Spicebush Swallowtail caterpillar changes from bright green to yellow-orange just before it enters the chrysalis phase.

its chrysalis, in about two weeks. If the insect enters its chrysalis phase during the cooler months of autumn, then it may wait out the winter by going into *diapause,* hibernating until warmer spring weather arrives. Sometimes butterflies that emerge in the spring are smaller than the ones that emerge during the summer months.

During the chrysalis phase, the caterpillar liquefies inside the chrysalis and reorganizes, almost magically transforming into a butterfly. Even after decades of research, all the details of this metamorphosis are not completely understood.

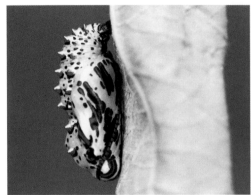

Variegated Fritillary

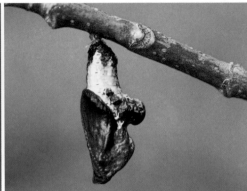

Viceroy

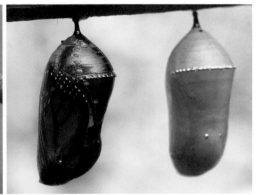

Monarch

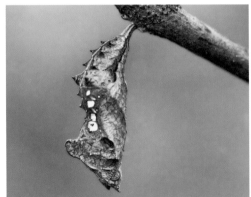

Question Mark

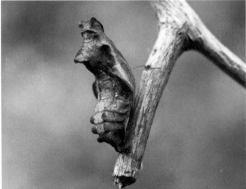

Pipevine Swallowtail

The great variety of coloration, shape, and decoration among chrysalises is evident from these photos. Although many chrysalises are fairly dull-colored for camouflage purposes, their decorative spikes and bulges make them fascinating to look at.

Butterfly Reborn

When the butterfly reaches maturity, a special hormone triggers a set of events that allow the adult insect to break free from its chrysalis shell. Entomologists believe the butterfly takes in air to swell itself up, causing the chrysalis to split open along specific weakened seams. In some species the chrysalis becomes transparent at this time, and you can actually see the pattern of the wings through the membrane.

Using its new long legs, the butterfly pulls itself out of the chrysalis and clings to the empty shell so that its crumpled wings can hang down freely. It begins to pump its wings slowly up and down, and constricts its body to force the yellowish insect blood, called *hemolymph,* into the wing veins so they can expand and open up to their full size.

As the veins fill with fluid, the wings stretch out and start to dry. The butterfly has only about an hour to extend its wings fully. If they aren't extended within this time period, they will harden in their folded position and be permanently deformed. It is vital that the butterfly not be handled or disturbed at this time. Without the ability to fly properly, the butterfly cannot live for very long.

▶ (TOP) The chrysalis splits at the seams and the Silvery Checkerspot pulls itself out. (MIDDLE) The wet wings are crumpled and must stretch out before they dry. (BOTTOM) The tongue is in two pieces and must be "zipped" together before it will function.

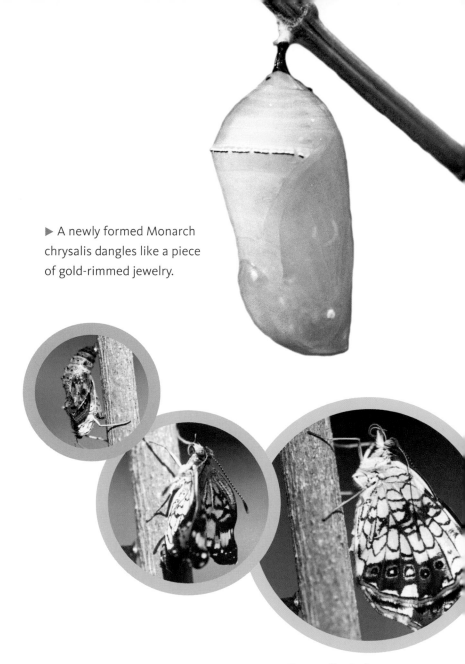

▶ A newly formed Monarch chrysalis dangles like a piece of gold-rimmed jewelry.

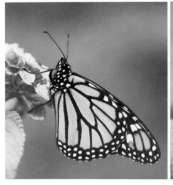

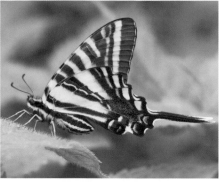

▲ Monarch.　　　　　▲ Zebra Swallowtail.

During this time, the butterfly must also fuse the two halves of its tongue, called the *proboscis.* By using microscopic muscles, the butterfly interlocks the halves to form a tube. It will use the tube to suck the nectar and other fluids it needs to survive. If a butterfly is unable to fuse its tongue, it will starve.

After a short time, the newly emerged butterfly excretes a fluid called *meconium,* the liquid waste left over from metamorphosis. Once its wings are completely dry and its tongue is in working order, the butterfly takes to the air.

How a Butterfly Experiences the World

A butterfly emerges from its chrysalis as a fully grown adult. You may see different sizes of the same species of butterfly, but often the difference is due to factors such as weather and food supply that affected the growing caterpillar. Sometimes the males and females of a species are naturally different sizes; usually the egg-carrying female is larger.

Most summertime butterflies have a very short life span: about a week or two. During that time the butterflies focus mainly on searching for food and finding a mate. They rely heavily on their keen senses of sight, smell, and taste to locate all the things they need to survive and reproduce.

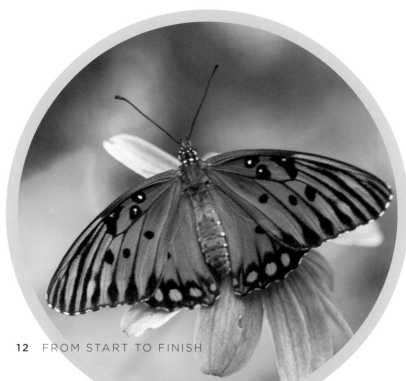

◀ The scales on the wings of this Gulf Fritillary are colored by pigments. With its wings wide open, the butterfly absorbs heat from the early-morning sun to dry off last night's dew.

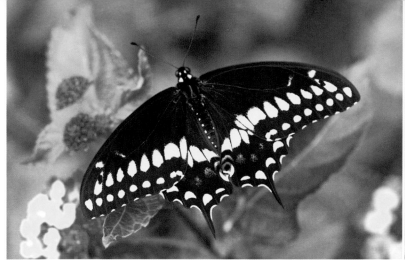

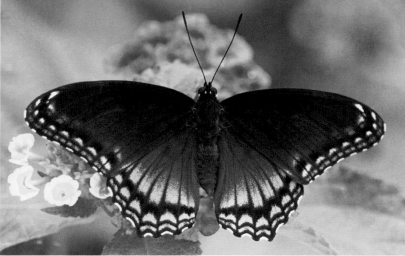

▲ We can tell that this Eastern Black Swallowtail is a male because of the row of large, light-colored spots across the middle of the wings. Females have smaller spots, and more blue on the lower wings.

▲ Red-spotted Purple . . . male or female? To the human eye, the male and female of a butterfly species can be difficult to tell apart.

Sight

Butterflies have large eyes that can see many colors, including those in the ultraviolet range that humans can't see. If we use special lighting, we're able to observe that many flowers almost glow with ultraviolet patterns. To the butterflies, these flowers must look like brightly lit runways! Butterflies can also detect movement better than we can — that's why it can be so difficult to sneak up on them. If a male butterfly sees something fly by that looks like a possible mate, he'll move quickly to investigate. If it turns out to be a rival suitor, he may chase him out of the area to prevent any competition. If it's a female, he'll pursue her, performing his best aerial acrobatics.

Smell and Taste

With the chemical receptors on their antennae, butterflies can detect odors in the air. They can locate food, potential mates, and perhaps other things that we don't even know about. When a butterfly lands on a flower, a mushy fruit, or a patch of tree sap, it can taste the food with its tongue and its feet. The length of a butterfly's tongue varies by species. Some are capable of feeding from long tubular flowers; those with a shorter tongue must sip from flatter-faced blooms.

Wonderful Wings

You're not likely to see many active butterflies when the temperature is below 50°F/10°C. Like all other insects, butterflies

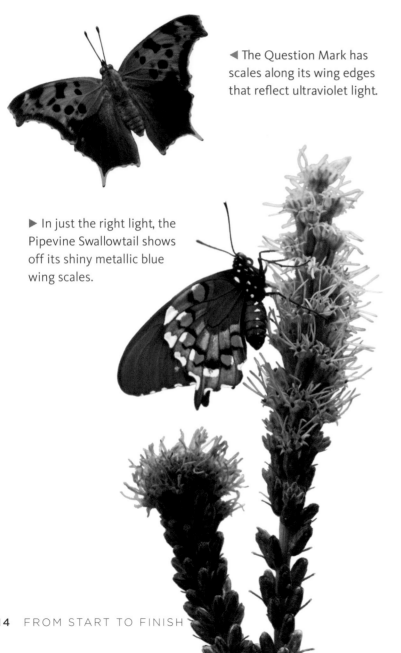

◀ The Question Mark has scales along its wing edges that reflect ultraviolet light.

▶ In just the right light, the Pipevine Swallowtail shows off its shiny metallic blue wing scales.

are cold-blooded and must bask in the sun on cool days to warm up their flight muscles before they are able to fly. We often see butterflies sunbathing on our stepping-stones.

The thousands of dusty scales that cover a butterfly's wings and body absorb heat from the sun. The butterfly can make its wings tremble and shiver to help speed up the warming process. It knows exactly how to orient its wings to the sun so it can absorb heat more quickly. This is important, as a sitting butterfly is vulnerable to attack.

Some butterflies seem to need more heat than others do. We have observed Mourning Cloak and Question Mark butterflies flying around on very chilly mornings, hours before other species even attempt to fly.

The scales covering the wings and body also give a butterfly its pretty colors. Some scales are colored by pigments; others are iridescent, appearing shiny or metallic because of the way light hits them. A few are transparent. The scales are loosely attached to the wings and overlap each other, rubbing off easily when touched. This prevents things from sticking to the wings and may make the wings more difficult for a predator to grasp.

Wing scale colors allow butterflies to recognize each other. Many scales reflect ultraviolet light and act as markers, so species look different from one another. Males and females of the same species also look different from each other. Our eyes can only see these subtle patterns if we view a butterfly under special lighting.

Continuing the Cycle

Most summertime butterflies live only a week or two. Within that short time they urgently seek out a mate so they can reproduce. Because they also need to find food, take shelter from bad weather, and avoid hungry predators, locating a mate can be a daunting challenge.

Each species of butterfly produces its own pheromones (chemicals that stimulate mating behavior). Potential mates can smell pheromones from a distance, which is a more reliable way of finding each other than just depending on a chance meeting.

Once a male and female have sighted each other, some species begin elaborate courtship "dances" involving a lot of chasing and aerial stunts. The male shows off his ultraviolet-reflective wings and the female decides if he's worthy of her attention. On a few occasions we've seen a butterfly get his signals crossed and attempt to mate with a female of a different species. This usually results in the male getting a quick wing slap from the female. Sometimes butterflies will fight if more than one male approaches the same female.

Some male butterflies are so eager to mate that they seek newly emerged females that are still drying their wings. Since the female can't fly yet, the male's success is guaranteed. This strategy saves the male the trouble of impressing a female with his fancy flying by chasing after her, and it allows him to spend his extra time and energy looking for another available mate.

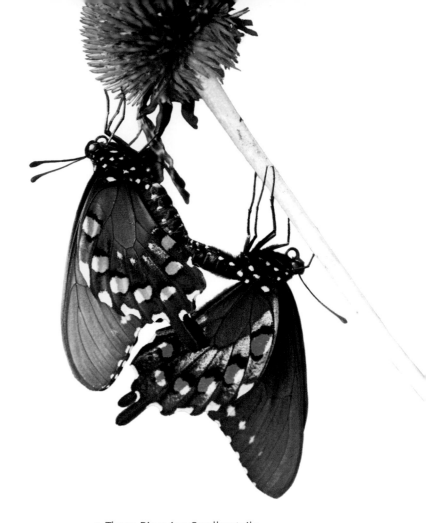

▲ These Pipevine Swallowtails have perched on the seed head of a coneflower to maneuver into mating position.

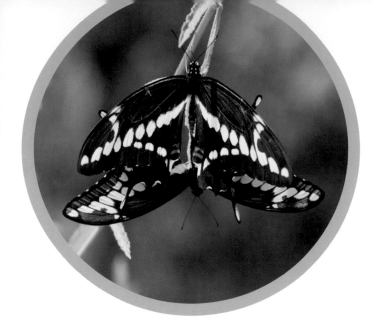

▲ The male Giant Swallowtail uses special claspers on the tip of his abdomen to hold the female's abdomen against his own.

Male butterflies employ various techniques to scout for a potential mate. When *hilltopping,* the male lingers at the top of a hill or a tall stand of trees, where he can get a bird's-eye view of the area. Females that need to find a mate instinctively visit landmarks that can be seen from a distance.

Other males may try *perching.* This means they pick out a sunny spot in an area where lots of butterflies congregate and then just sit and wait. When something of interest passes by, they dart out to investigate. They may continue this behavior for as long as several hours or until they've found a mate, unless they give up and move on.

Male butterflies often gather in groups at muddy areas, especially those next to streams, to sip dissolved salts and minerals. This behavior, called *puddling,* may provide the extra nutrients males need for mating.

Another mate-finding technique is *patrolling.* The male finds a dividing line where one type of habitat meets another, and he actually patrols the area. A stream cutting through woods or a stand of trees at the edge of an open field is a good example of this type of transitional area. Sometimes the male will also patrol areas where host plants grow, in the hope of finding a female that has just emerged from her chrysalis.

A DAY IN THE LIFE OF A *Butterfly*

IT'S A CHILLY SPRING MORNING when the butterfly awakens. Droplets of dew glisten like diamonds in the early light as they cling to closed wings, thin legs, and delicate antennae. As the sun rises and a breeze begins to stir, the moisture slowly evaporates. The butterfly opens its wings and turns to absorb the heat from the sun's rays. After its flight muscles are warm enough, the butterfly flutters away from its evening roost to explore its surroundings.

Food is the first priority. Tempting flowers dance in fields and wild places. The hungry butterfly finds a patch of coneflowers and lands to sample the sugary treat. Its long tongue uncurls like a streamer and carefully explores each blossom. Each flower offers up just a smidgen of nectar, so the butterfly must sample many more to satisfy its appetite.

After a morning of successfully dodging predators and drinking lots of nectar, the butterfly is ready to look for a mate. A male butterfly often lingers at the edge of a field and along the top of a hill, looking for the newly emerged females that fly through his territory. Then real chemistry comes into play: The male's pheromones attract females, and if a female finds the male suitable, she allows the male to mate with her.

The male has special claspers on the tip of his abdomen that hold the female's abdomen flush with his own so he can deliver a packet of sperm to her. Normally, the butterflies must perch on something in order to maneuver into the end-to-end mating position. They remain connected for several minutes or longer.

Now the pregnant female needs to find a host plant for her eggs. She seeks plants that will provide enough food for all her offspring. Ideally, she'll lay just a few eggs on each plant, so the soon-to-be caterpillars will not have to compete with each other for their daily meals.

Laying all her eggs (and there may be hundreds) can take several days. As the sunlight begins to fade into dusk and the temperature drops, she must find a place to roost in safety during the night so she can start all over the next day. Sadly, once she has outwitted predators and struggled through wind and rain to deposit her precious eggs, the butterfly doesn't live for very much longer. But with a little luck, the next generation of beautiful butterflies will soon follow.

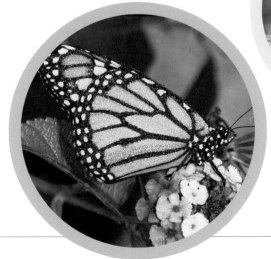

▲ Red Admiral on a coneflower.

◀ A Monarch wet with morning dew.

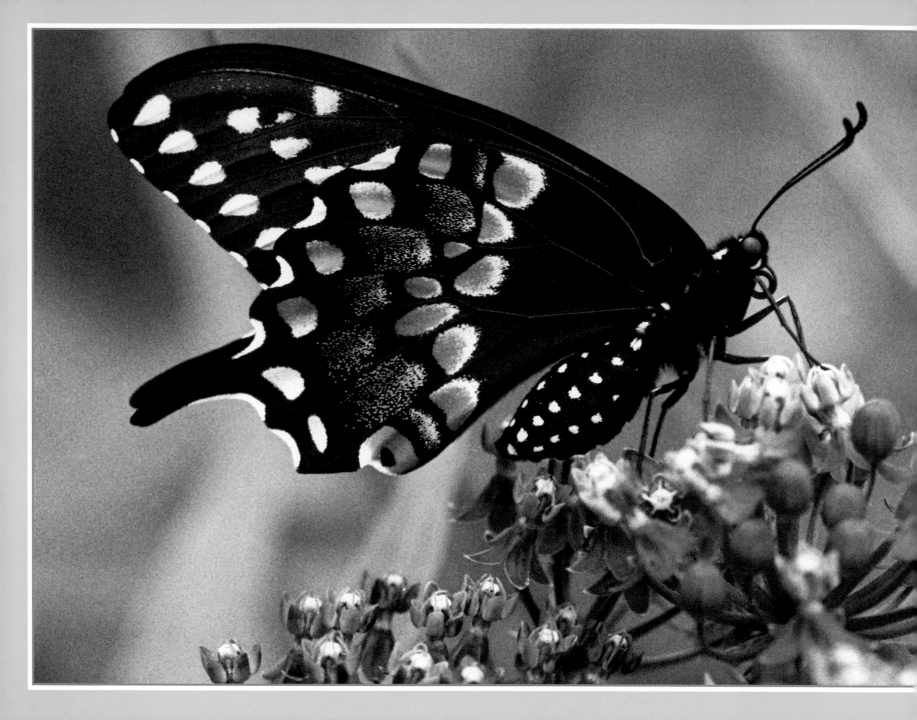

Butterfly Life Cycles

THE FOLLOWING PAGES DOCUMENT the complete life cycle of 23 common species of butterflies, organized according to family. We've taken most of these photographs and included our own observations. We've also included photographs of cultivated as well as some wild host and nectar plants and cross-referenced the cultivated plants with information in the next chapter.

Other helpful features of this chapter include range maps and life-cycle timelines. Range maps show you where the butterflies tend to live and how many generations, or broods, occur there per year. Because caterpillars grow faster in warm and dry weather, butterflies living in the South will have more generations per year than those living in the North. Life-cycle timelines show you when the butterflies are active and most likely to be seen.

If you're out in the field or the flower garden and spot an egg, caterpillar, or chrysalis that you can't identify, flip to pages 146–148. Then flip back to this chapter to get more in-depth information.

Eastern Black Swallowtail

(PAPILIO POLYXENES)

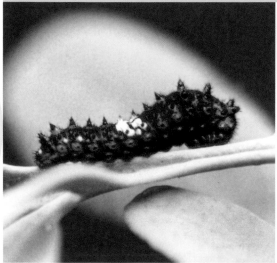

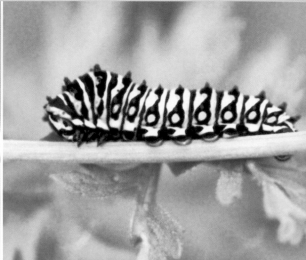

You can find single eggs on the upper surface of a leaf and also on the stems and flowers of the host plant.

In its earliest stages, the caterpillar is dark and covered in tiny spikes. It has a patch of white on top, called a *saddle*.

As the caterpillar matures, it gradually loses its spikes and becomes striped and spotted.

WE LOVE TO WATCH the lazy back-and-forth movements of these velvety beauties as they sample wild milkweed in meadows and gardens. It's easy to see them with wings open or closed: They always fan their wings as they feed.

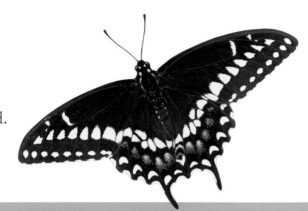

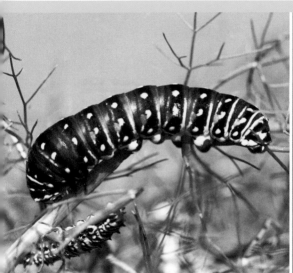

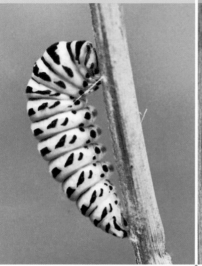

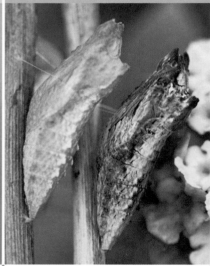

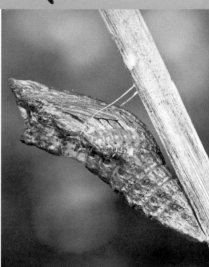

Usually the caterpillars are green with black bands, but sometimes we see a black one like this. All have yellow spots on each body segment.

When the caterpillar is ready for the next phase, it hangs upright on a twig and spins a silk thread, or *girdle*, around its body.

The chrysalises may vary in color from bright green and yellow to dull brown and tan. In the fall they go into diapause until spring.

Just before the butterfly is ready to emerge, the chrysalis turns clear and you can see the wing markings.

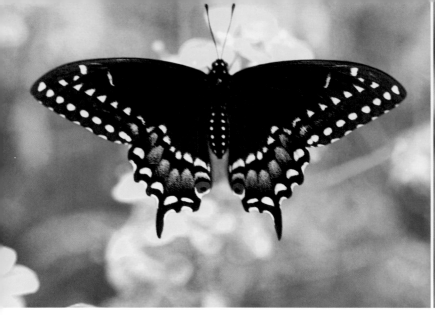

▲ The colors on the top surface of the open wings look very different from those on the closed wings. The blue is so bright, on this female, that it seems almost to glow.

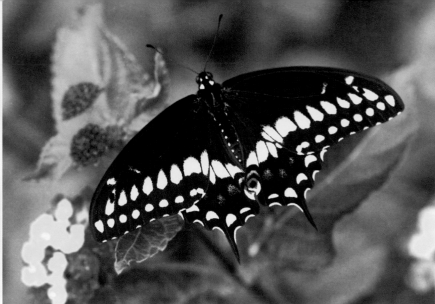

▲ Males are mostly black with yellowish spots.

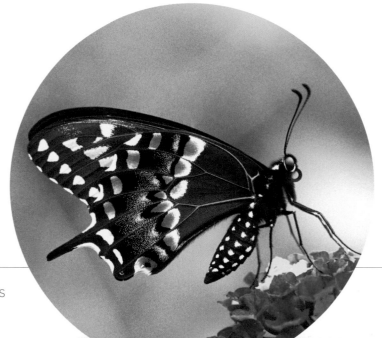

◄ When the butterfly is at rest, the bright orange spots on the underside of the wings are visible.

Eastern Black Swallowtail

* **Like other swallowtail caterpillars,** the Black Swallowtail caterpillar (also known as the Parsley caterpillar) has a forked orange scent gland, called an osmeterium, that pops out to emit a nasty odor when the caterpillar feels threatened.

* **The Black Swallowtail's coloration** is very much like the Pipevine Swallowtail's. The fact that the Pipevine Swallowtail tastes bad may deter some of the Black Swallowtail's predators.

* **The male Black Swallowtail** has a row of large, light-colored spots across the middle of his wings.

* **The female** has much smaller spots across her wings, and she wears a larger patch of beautiful blue scales on each lower wing.

* **Many kinds of plants are hosts** to the Black Swallowtail, but we've had the most luck with fennel, dill, and Queen Anne's lace (also called wild carrot).

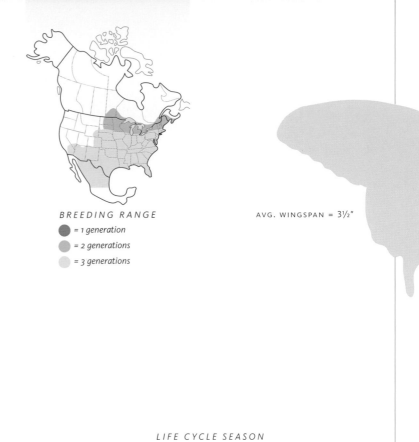

BREEDING RANGE
- = 1 generation
- = 2 generations
- = 3 generations

AVG. WINGSPAN = 3½"

LIFE CYCLE SEASON

MAR	APR	MAY	JUN	JUL	AUG	SEP	OCT

HOST PLANTS

NECTAR PLANTS

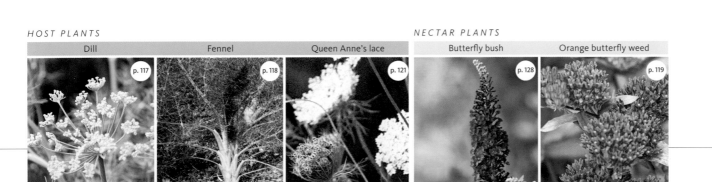

Dill	Fennel	Queen Anne's lace	Butterfly bush	Orange butterfly weed
p. 117	p. 118	p. 121	p. 128	p. 119

Giant Swallowtail

(PAPILIO CRESPHONTES)

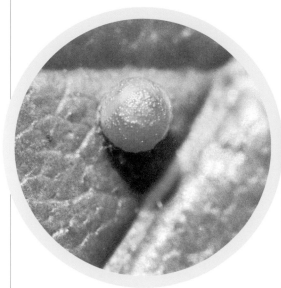

Giant Swallowtails lay their eggs on the top surface of plant leaves. The orange eggs darken before they hatch.

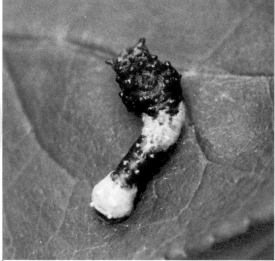

The young caterpillar is glossy and has bumps on its skin. Its colors make it look like a bird dropping, so birds are less likely to eat it.

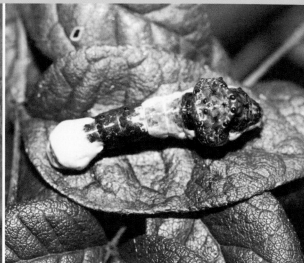

The caterpillar undergoes some minor changes in color and overall appearance in its several molts.

FROM A HOMELY BROWNISH CATERPILLAR comes one of the largest of all North American butterflies. Some are as big as six inches across! Because the caterpillars feed on citrus leaves and the butterflies love citrus blossom nectar, the Giant Swallowtail is sometimes nicknamed "Orange Dog."

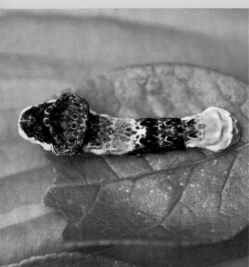

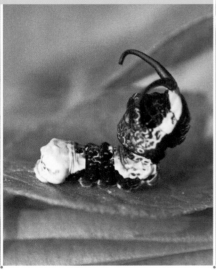

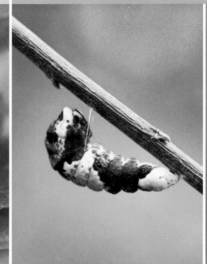

The caterpillar grows to a length of about two inches during this stage.

When it feels threatened, the caterpillar extends a foul-smelling gland called an osmeterium, which looks like a snake's tongue.

When the caterpillar is ready to change into a chrysalis, it hangs from a stem and spins a silk thread around its body.

The chrysalis is various shades of brown, sometimes with patches of green that look like lichen growth. The chrysalis remains in place through the winter.

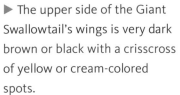
► The upper side of the Giant Swallowtail's wings is very dark brown or black with a crisscross of yellow or cream-colored spots.

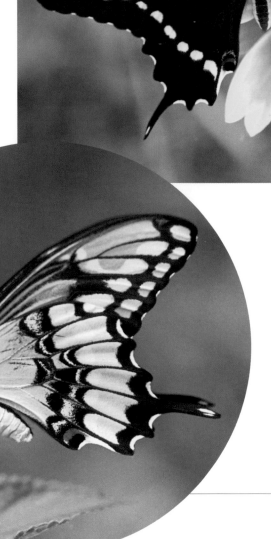

◄ The underside of the wings is pale yellow, with iridescent light blue patches of scales on the lower wings.

Giant Swallowtail

* **You'll know the Giant Swallowtail** by the two bands of yellow spots that extend across its open wings.

* **Because of their affection for tender leaves,** large groups of Giant Swallowtail caterpillars may defoliate small young citrus trees.

* **We've found our prickly ash most successful** in attracting Giant Swallowtails, but the butterflies will also lay eggs, in smaller amounts, on our rue herbs. Both plants prefer full sun and well-drained soil. Prickly ash does have thorns, so be extra careful when handling this shrubby tree.

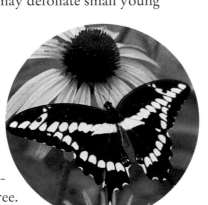

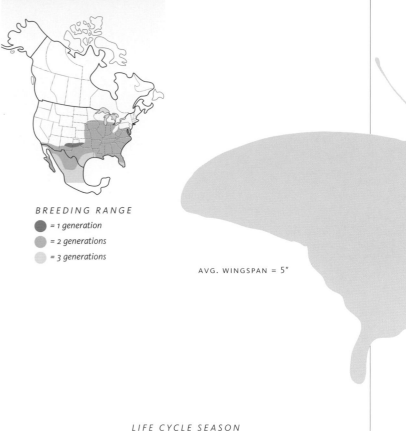

BREEDING RANGE

● = *1 generation*
● = *2 generations*
○ = *3 generations*

AVG. WINGSPAN = 5"

LIFE CYCLE SEASON

| MAR | APR | MAY | JUN | JUL | AUG | SEP | OCT |

HOST PLANTS

NECTAR PLANTS

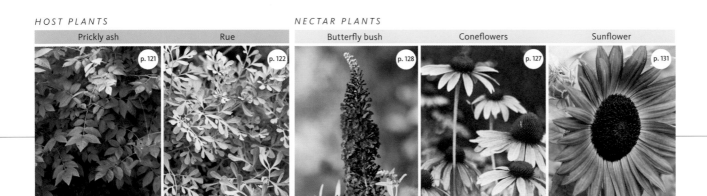

| Prickly ash | Rue | Butterfly bush | Coneflowers | Sunflower |
| p. 121 | p. 122 | p. 128 | p. 127 | p. 131 |

Pipevine Swallowtail

(BATTUS PHILENOR)

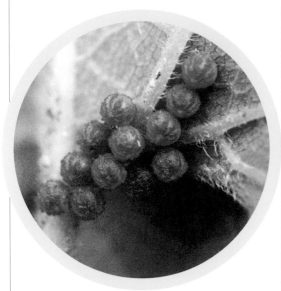

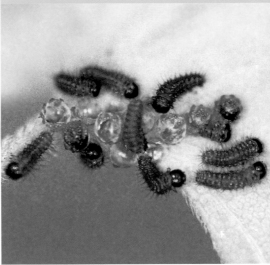

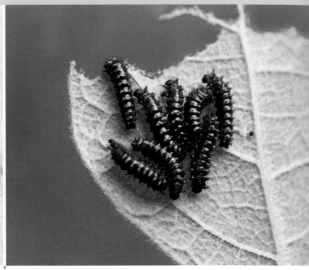

The female lays eggs in clusters around the stems and leaves of the host, Dutchman's pipevine.

The first thing the newly hatched caterpillars do is eat their own eggshells before starting to chew on the plant leaves.

Most butterfly caterpillars are solitary feeders, but the Pipevines stay in groups and eat together at the edge of a leaf.

If imitation is the sincerest form of flattery, lots of other butterflies want to flatter the Pipevine Swallowtail! Because of its iridescent blue scales, this elegant, medium-sized butterfly can easily be mistaken for the dark-color form of the Tiger Swallowtail or the female forms of the Eastern Black Swallowtail, Spicebush Swallowtail, and Red-spotted Purple. We always look twice.

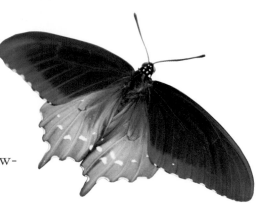

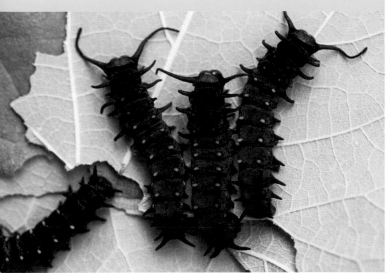

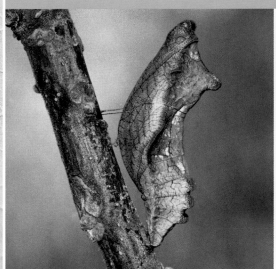

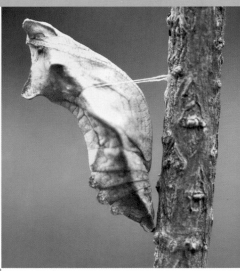

As they mature, the caterpillars change from orange to velvety black with fleshy orange spikes.

The chrysalis looks similar to other swallowtail butterfly chrysalises but has a few more bumps at the base.

The chrysalis may be tan and brown or a mix of green and yellow. It will stay in diapause all winter.

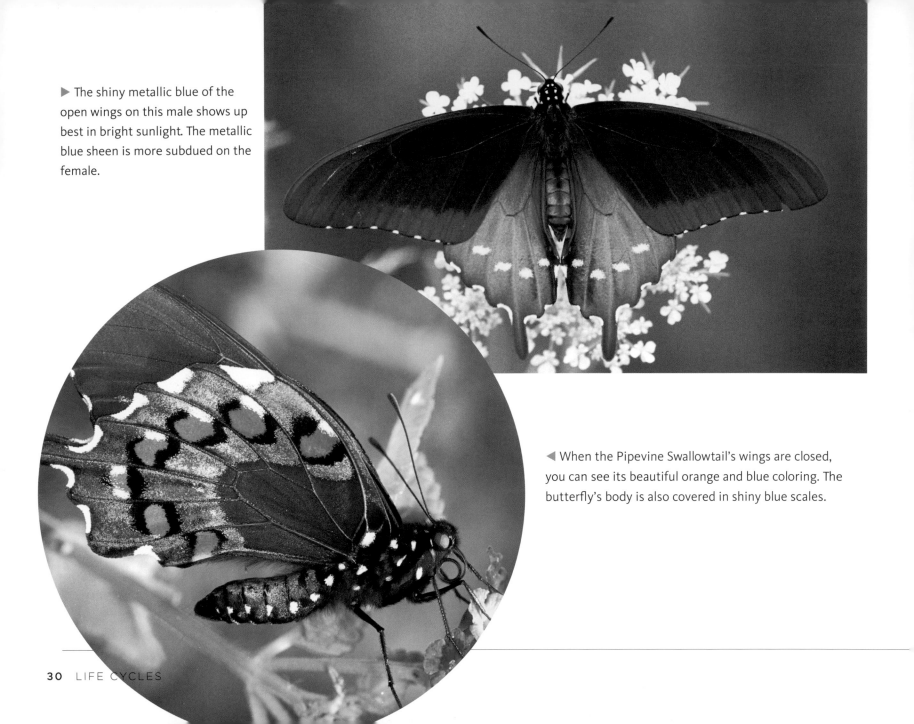

▶ The shiny metallic blue of the open wings on this male shows up best in bright sunlight. The metallic blue sheen is more subdued on the female.

◀ When the Pipevine Swallowtail's wings are closed, you can see its beautiful orange and blue coloring. The butterfly's body is also covered in shiny blue scales.

Pipevine Swallowtail

* **Birds and other predators** find both the caterpillar and the butterfly forms of the Pipevine Swallowtail distasteful. Pipevine plants contain aristolochic acid, which is toxic to some animals.

* **Pipevine Swallowtail males** have more metallic blue color than do the females. The females have more prominent white spots on their wings.

* **Fond of colorful flowers,** Pipevines flutter constantly as they drink nectar, but don't linger long at any one bloom. They are timid and nervous when approached and are strong, quick fliers that soar across our yards in a flash.

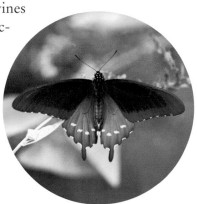

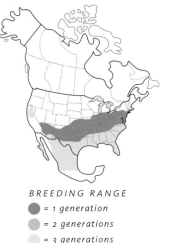

BREEDING RANGE

● = 1 generation
● = 2 generations
● = 3 generations

AVG. WINGSPAN = 3¾"

LIFE CYCLE SEASON

| MAR | APR | MAY | JUN | JUL | AUG | SEP | OCT |

HOST PLANT

NECTAR PLANTS

Pipevine	Butterfly bush	Mexican sunflower	Swamp milkweed	Tall garden phlox
p. 120	p. 128	p. 130	p. 129	p. 130

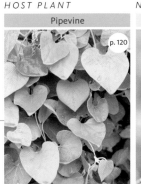

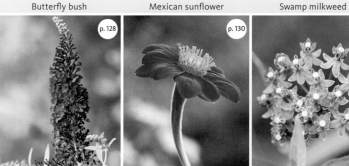

Spicebush Swallowtail

(PAPILIO TROILUS)

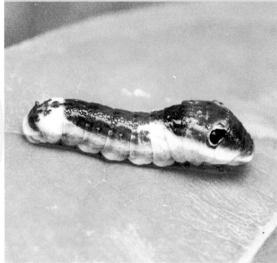

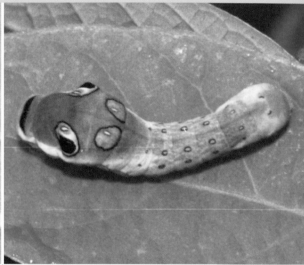

Single round eggs that look like tiny pearls are glued onto the underside of the host plant's leaves.

The color and physical appearance of the caterpillar changes with each molt. The young caterpillar is brown and glossy.

As it grows and matures, the caterpillar turns greenish with blue dots. Too big now to pass for a bird dropping, the caterpillar's green skin allows it to blend in among the plant leaves.

As dramatic as a cityscape at night, the velvety open wings of this woodland-loving butterfly are black, accented with brilliant white spots. In some places it's called the Green-clouded Swallowtail because of the hazy blue-green of the male's lower wings.

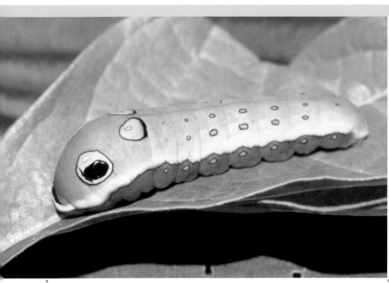

What large eyes it has! Actually, these are false eye-spots. The real head stays hidden under the front skin. At this stage you can see bright blue dots on the caterpillar's translucent pink legs.

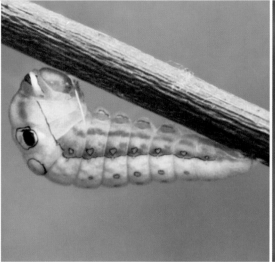

When the caterpillar is ready for the next phase, it turns pale yellow and hangs from a twig by spinning a silk thread around itself.

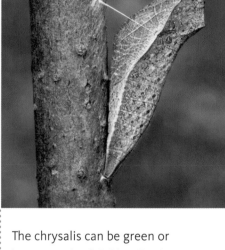

The chrysalis can be green or brown. In the fall, like all other swallowtails in northern states, it enters diapause until spring.

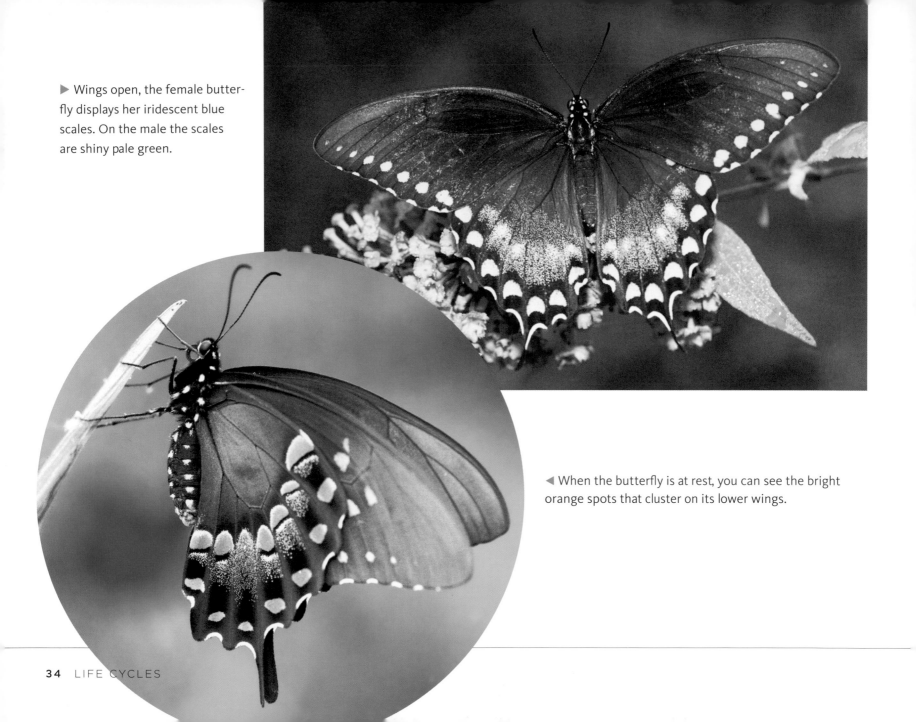

▶ Wings open, the female butterfly displays her iridescent blue scales. On the male the scales are shiny pale green.

◀ When the butterfly is at rest, you can see the bright orange spots that cluster on its lower wings.

Spicebush Swallowtail

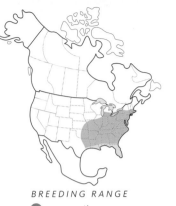

* **The caterpillar spins a mat of silk,** which shrinks as it dries, curling the leaf's edges. This gives the caterpillar a place to hide all day.

* **Look for folded spicebush leaves** and you'll locate sleeping caterpillars inside. They come out at night to eat.

* **Wrens in our yards** bite through the center of a folded spicebush leaf to eat the caterpillar inside. Some spiders also use their silk to fold over a leaf and hide this way, but the wrens are insect eaters, so they win a meal either way.

* **Spicebush butterflies** are drawn to the nectar of our butterfly bushes and lantanas.

BREEDING RANGE

● = 1 generation
● = 2 generations
● = 3 generations

AVG. WINGSPAN = 4¼"

LIFE CYCLE SEASON

| MAR | APR | MAY | JUN | JUL | AUG | SEP | OCT |

HOST PLANT

Spicebush
p. 122

NECTAR PLANTS

Butterfly bush
p. 128

Coneflowers
p. 127

Lantana
p. 128

Sunflower
p. 131

Tiger Swallowtail

(PAPILIO GLAUCUS)

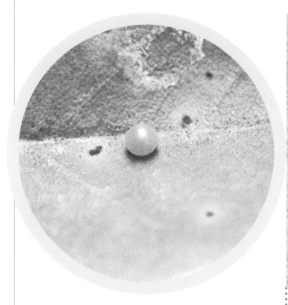

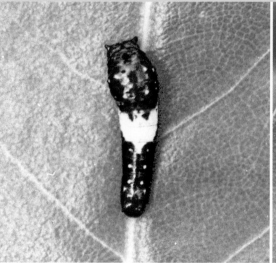

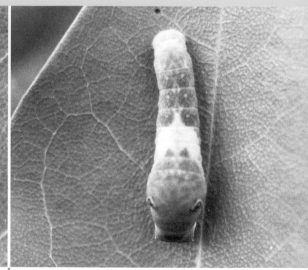

Look for single round green eggs laid on the top of a leaf. The eggs blend in very well with surrounding foliage.

At first the caterpillar is brownish with a white midsection. Some people mistake caterpillars at this stage for bird droppings.

As it sheds its skin, the caterpillar becomes a beautiful light green with two small yellow-orange and black eyespots. The front of the caterpillar looks swollen compared to the back.

Have you ever seen a group of large butterflies gathered at a mud puddle? They could be Tiger Swallowtail males, sipping the salts and minerals they need for reproduction. You'll recognize them by the tigerlike yellow and black stripes across their wings and the long, thin black "tail" that extends from each lower wing.

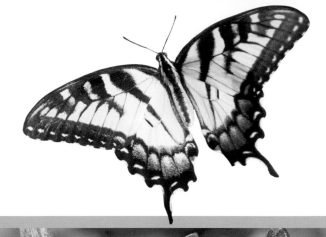

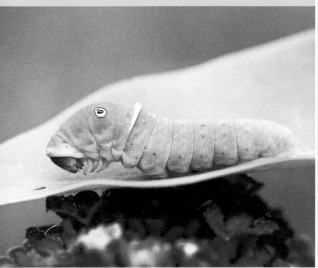

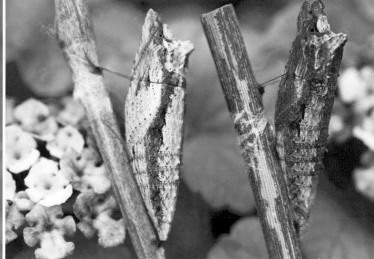

This caterpillar is spinning a mat of silk threads to cover the top of the leaf. When the silk dries, it shrinks and folds the leaf, creating a place to hide from predators.

The caterpillar turns dark brown when it is ready to pupate. A silk thread holds it upright on a stick as it prepares to shed its skin one last time.

The chrysalis may be green or shades of brown. In the autumn it enters diapause until spring, when the butterfly emerges. These two chrysalises look like branches on the twigs.

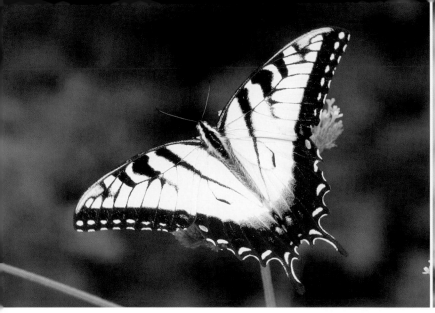

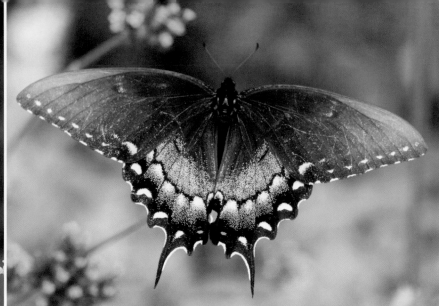

▲ The male Tiger Swallowtail is yellow with bold black stripes, like a real tiger.

▲ Female Tiger Swallowtails may exhibit this second color form, called *dimorphic coloration*. This dark-colored female form is more common in Georgia and Florida than elsewhere in the butterfly's range.

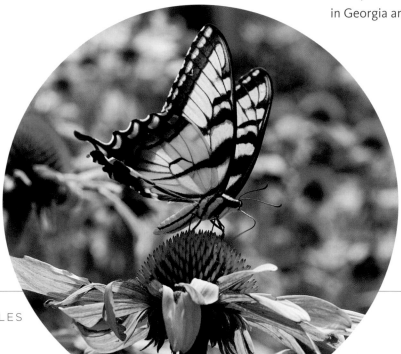

◀ Only with the wings closed can you see the bright orange spots that decorate the underside of the bottom wings.

Tiger Swallowtail

* **A disturbed Tiger Swallowtail caterpillar** will sometimes rear up and head-butt anything that gets close.

* **This butterfly's long tongue** enables it to reach into tubular flowers and sip nectar that other butterflies can't reach.

* **Most Tiger Swallowtails lay eggs in treetops,** one egg to a leaf. Locating the eggs and caterpillars can be difficult unless you keep your trees pruned. To find a caterpillar, look for a curled-up leaf being used as a hiding place. Partially eaten leaves may also give away the caterpillar's location.

* **Several types of trees,** including sweet bay magnolia and tulip poplar, are common hosts. The sweet bay is a relatively small tree with a rather sparse leaf count. The tulip tree, on the other hand, can grow to be several stories tall and requires more space in your yard.

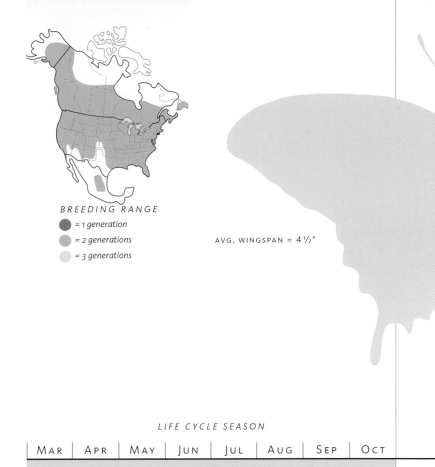

BREEDING RANGE

● = 1 generation
● = 2 generations
● = 3 generations

AVG. WINGSPAN = 4 ½"

LIFE CYCLE SEASON

MAR	APR	MAY	JUN	JUL	AUG	SEP	OCT

HOST PLANTS

NECTAR PLANTS

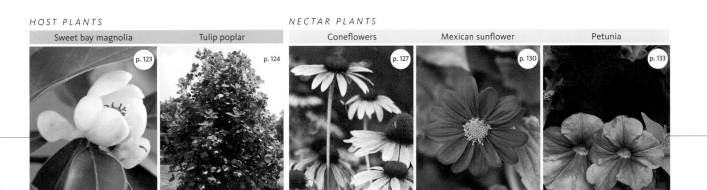

Sweet bay magnolia	Tulip poplar	Coneflowers	Mexican sunflower	Petunia
p. 123	p. 124	p. 127	p. 130	p. 133

Zebra Swallowtail

(EURYTIDES MARCELLUS)

These two eggs were laid by the same female. The empty-looking one is a "dud"; the green one will hatch.

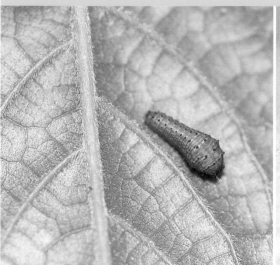

At first the caterpillar is bluish gray with tiny stripes. At this stage it looks like a little slug.

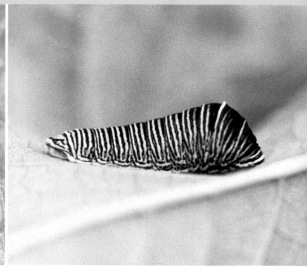

We've seen caterpillars ranging in color from shades of green to occasionally black, like this one.

With its long kite tails and graceful gliding flight, the Zebra Swallowtail is a delightful show-off. We're glad the pawpaw tree is common where we live, because it's the only tree Zebras lay their eggs on.

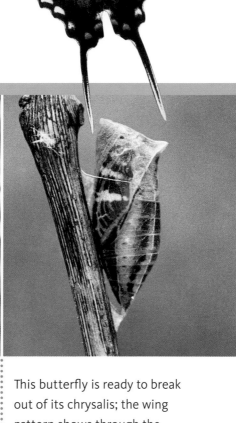

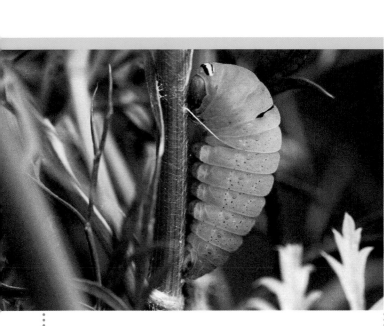

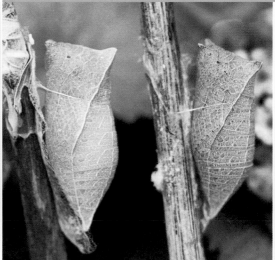

When it's ready to pupate, the caterpillar hangs upright from a stem and spins a silk harness around itself.

Compared with other swallowtail chrysalises, these seem small and compact, especially considering that such large butterflies emerge from them.

This butterfly is ready to break out of its chrysalis; the wing pattern shows through the chrysalis shell.

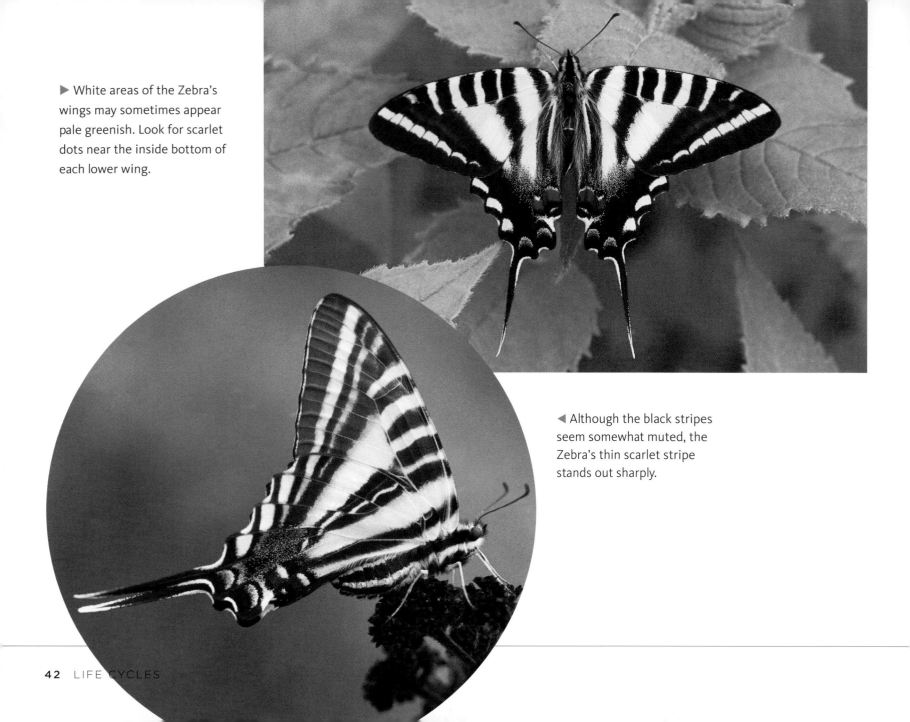

▶ White areas of the Zebra's wings may sometimes appear pale greenish. Look for scarlet dots near the inside bottom of each lower wing.

◀ Although the black stripes seem somewhat muted, the Zebra's thin scarlet stripe stands out sharply.

Zebra Swallowtail

FIELD NOTES

＊ **The longest tails** of any butterfly in North America belong to the Zebra. Its tails and triangular wings make it part of the Kite family of butterflies.

＊ **Zebras emerging in spring** have shorter tails and may be paler than those that emerge in summer.

＊ **The only host plant for the Zebra** is the pawpaw tree. It often grows in wooded areas near streams, and sprouts easily from large seeds.

＊ **Female Zebras are easy to approach** and photograph when they're focused on laying their eggs.

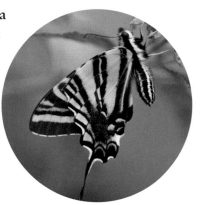

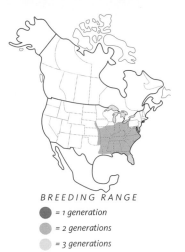

BREEDING RANGE

● = 1 generation
● = 2 generations
● = 3 generations

AVG. WINGSPAN = 3½"

LIFE CYCLE SEASON

| MAR | APR | MAY | JUN | JUL | AUG | SEP | OCT |

HOST PLANT
Pawpaw — p. 120

NECTAR PLANTS
Cosmos — p. 132
Milkweed — p. 129
Sweet William — p. 132
Zinnia — p. 131

Gulf Fritillary

(AGRAULIS VANILLAE)

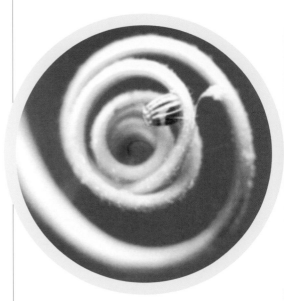

The Gulf Fritillary female lays her eggs on passion vines, especially on the curly, spiraling tendrils.

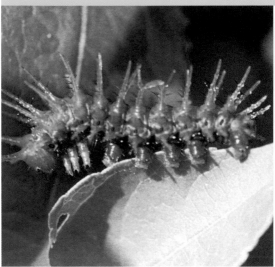

This caterpillar has just molted. Until the new skin dries and hardens a bit, it's especially vulnerable to attack.

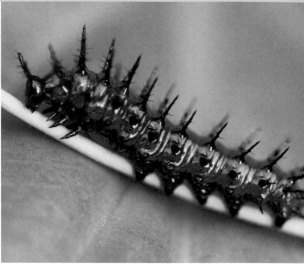

The caterpillar eventually turns dark orange and its spikes blacken. It eats the leaves and tendrils of the passion vine.

THE WARM AREAS AROUND THE GULF OF MEXICO are this butterfly's favorite neighborhoods, and like some exotic tropical creature, it lives on passionflowers. We love to watch it with its wings wide open, absorbing heat from the early-morning sun to dry off last night's dew.

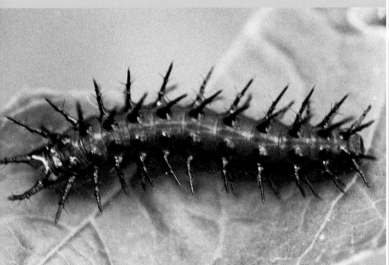

As the caterpillar grows, it becomes darker and glossier. The spikes look scary, but they're harmless.

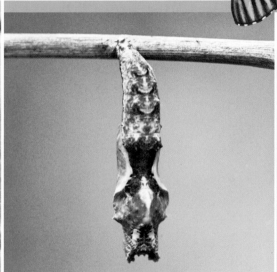

The chrysalis may be tan and cream-colored. It looks like a dead leaf.

Some chrysalises are dark brown. The deep indentation in the middle is typical for a Gulf Fritillary.

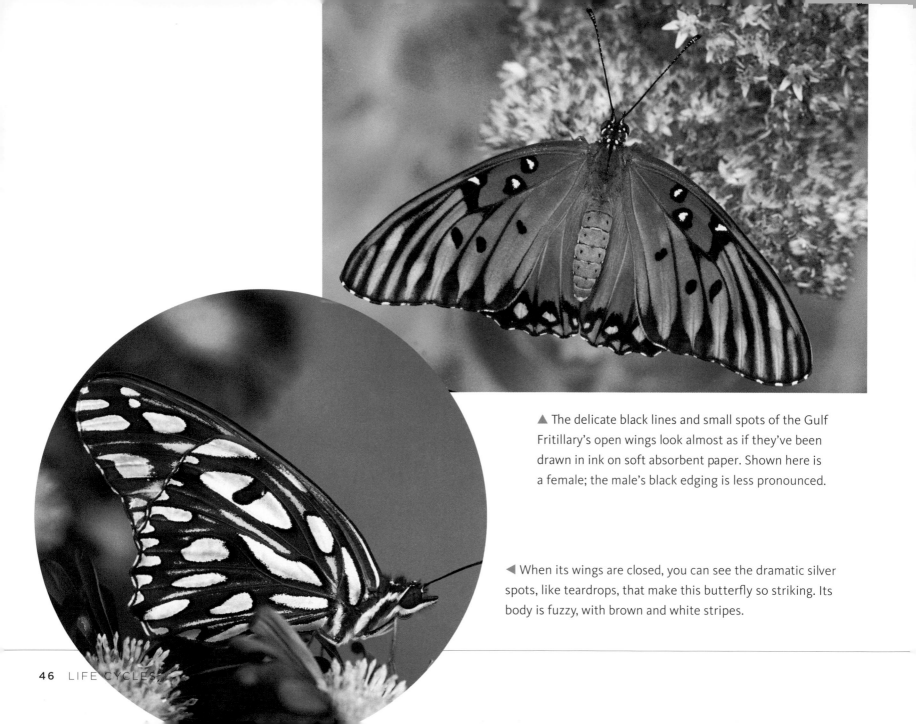

▲ The delicate black lines and small spots of the Gulf Fritillary's open wings look almost as if they've been drawn in ink on soft absorbent paper. Shown here is a female; the male's black edging is less pronounced.

◄ When its wings are closed, you can see the dramatic silver spots, like teardrops, that make this butterfly so striking. Its body is fuzzy, with brown and white stripes.

Gulf Fritillary

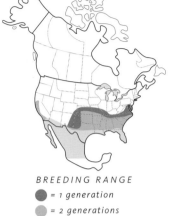

✳ **Although they normally frequent** the Gulf of Mexico, Gulf Fritillary females occasionally wander far enough north to lay their eggs on our passion vines.

✳ **Its diet makes the Gulf Fritillary caterpillar** poisonous to predators. The caterpillars favor passion vine flower buds.

✳ **Unable to survive freezing temperatures,** this butterfly stays in the warmer southern states all winter long.

✳ **Flashy silver spots** on the wings' undersides make Gulf Fritillaries easy to identify.

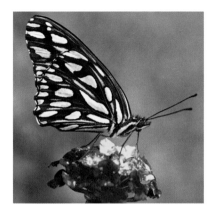

BREEDING RANGE

● = *1 generation*
○ = *2 generations*
○ = *3 generations*

AVG. WINGSPAN = 3½"

LIFE CYCLE SEASON

MAR	APR	MAY	JUN	JUL	AUG	SEP	OCT
FLORIDA, TEXAS, AND MEXICO							
OTHER STATES							

HOST PLANT

Passion vine

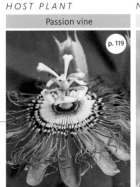

p. 119

NECTAR PLANTS

| Butterfly bush | Coneflowers | Lantana | Zinnia |

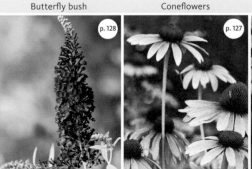

p. 128

p. 127

p. 128

p. 131

Variegated Fritillary

(EUPTOIETA CLAUDIA)

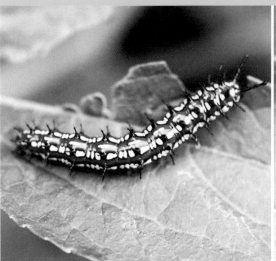

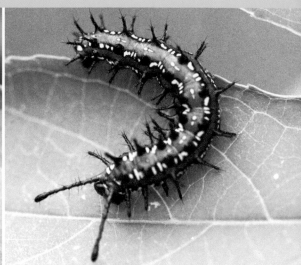

We've found cream-colored Variegated Fritillary eggs on several parts of our passion vines, including the leaves, stems, and tendrils.

The caterpillar changes very little in color and appearance when it sheds its skin. Its cousin the Gulf Fritillary lacks these white markings.

The mature caterpillar is glossy orange with white markings. It's covered in black spines with lots of branching points.

We're always delighted when Variegated Fritillaries appear in our gardens. They're common in southern states such as Georgia and Florida, but only occasionally wander north into our area. They fly with quick darting motions and stay close to the ground.

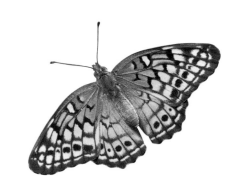

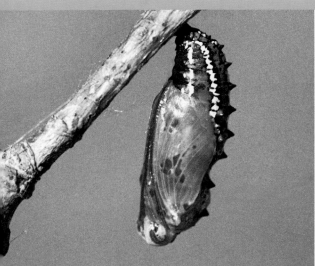

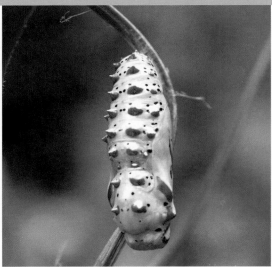

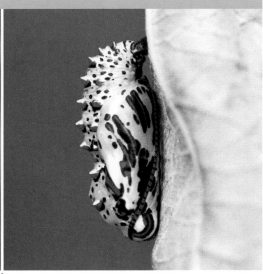

The caterpillar hangs upside down, ready to shed its skin for the last time. The skin has split open to reveal the chrysalis underneath.

Once it dries, the chrysalis has a beautiful mother-of-pearl sheen and is covered with golden spikes.

The color patterns of each chrysalis tend to be unique. Some are mostly white and others have lots of brown patches.

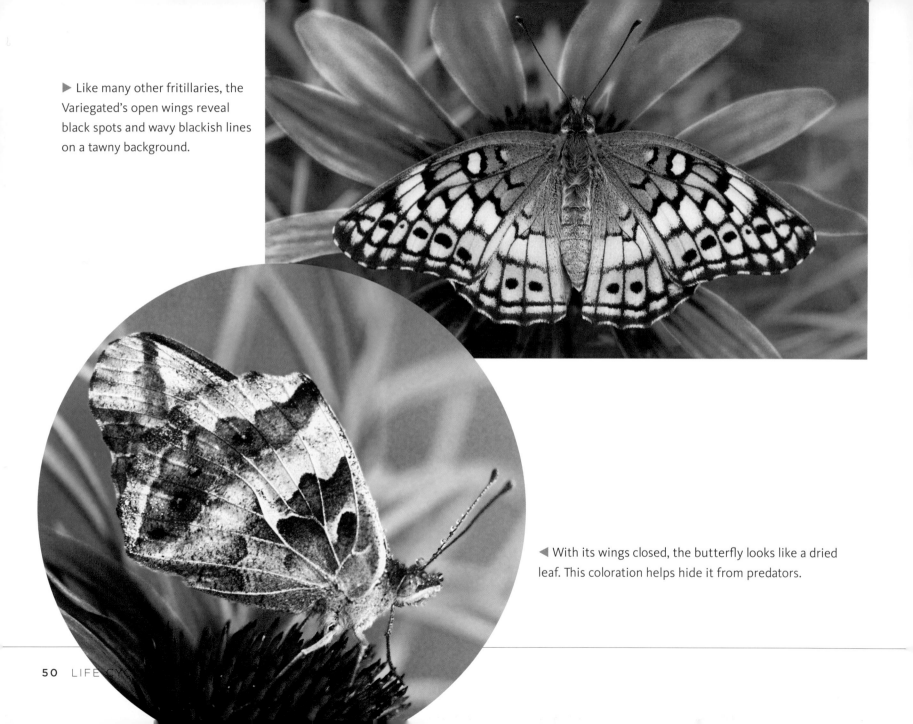

▶ Like many other fritillaries, the Variegated's open wings reveal black spots and wavy blackish lines on a tawny background.

◀ With its wings closed, the butterfly looks like a dried leaf. This coloration helps hide it from predators.

Variegated Fritillary

* **They may look a bit scary,** but these caterpillars won't sting or cause a rash if you handle them.

* **Unable to survive freezing temperatures** at any stage of its life cycle, the butterfly form of the Variegated Fritillary immigrates south to warmer regions during the winter.

* **Like other fritillaries,** Variegated caterpillars can eat violets. Like Longwings, they can also eat passion vines.

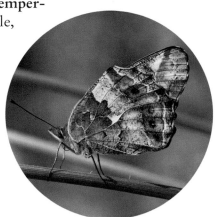

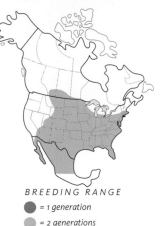

BREEDING RANGE AVG. WINGSPAN = 2¼"

● = 1 generation
● = 2 generations
● = 3 generations

LIFE CYCLE SEASON

MAR	APR	MAY	JUN	JUL	AUG	SEP	OCT
FLORIDA, TEXAS, AND MEXICO							
		OTHER STATES AND CANADA					

HOST PLANTS

Passion vine	Violet
p. 119	p. 124

NECTAR PLANTS

Butterfly bush	Coneflowers
p. 128	p. 127

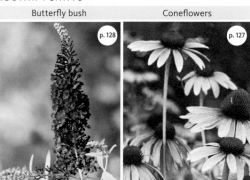

Zebra Longwing

(HELICONIUS CHARITONIUS)

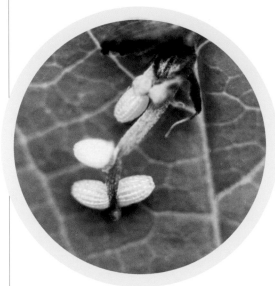

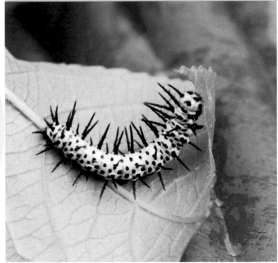

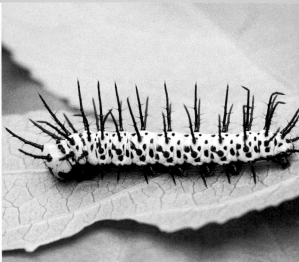

Zebra Longwings lay their yellow eggs on passion vines. We think the eggs look like miniature ears of corn.

The caterpillar is ghostly white and covered in prickly, branched black spines. Its appearance stays basically the same as it goes through several molts.

Although the spines look like little needles, they're actually flexible and won't hurt your skin.

THE NAME DESCRIBES IT WELL: Long striped wings, each punctuated with a curving row of pale yellow dots, give this striking butterfly elegance and grace. Look for groups of these butterflies at the forest's edge in the evening, as they like company when they sleep.

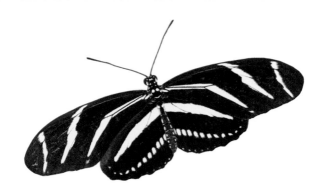

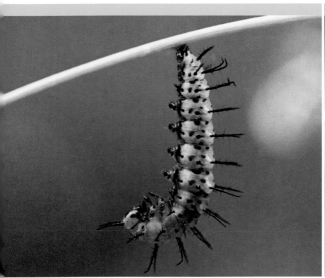

When the caterpillar hangs upside down to shed its skin for the last time, it turns pale brown.

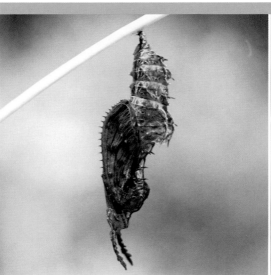

The chrysalis is light brown and covered in tiny barbs that may give it some protection against hungry predators.

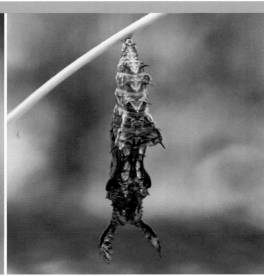

From this view, the chrysalis looks like a tiny bat hanging upside down.

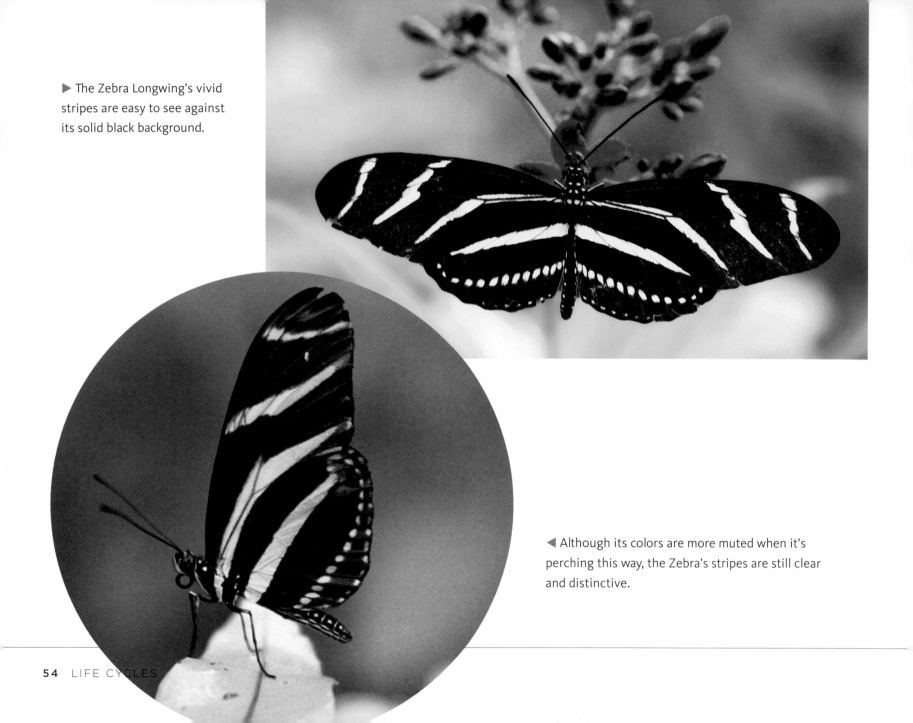

▶ The Zebra Longwing's vivid stripes are easy to see against its solid black background.

◀ Although its colors are more muted when it's perching this way, the Zebra's stripes are still clear and distinctive.

Zebra Longwing

* **A diet of passion vines** makes the Zebra Longwing caterpillar toxic to birds.

* **Although they normally live south of us,** Zebra Longwings occasionally visit our habitat gardens and lay eggs.

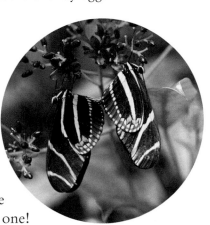

* **The Zebra's tongue secretes digestive enzymes** that help it digest protein-rich pollen specks as it "drinks." This supplement to its nectar diet allows the Zebra to live longer than other butterflies, perhaps by several months.

* **The Zebra's flight** is slow and meandering, in spite of those long wings. But just try to catch one!

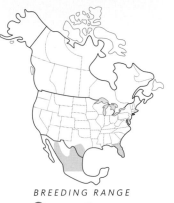

BREEDING RANGE

● = *1 generation*
● = *2 generations*
● = *3 generations*

AVG. WINGSPAN = 3 ¼"

LIFE CYCLE SEASON

Mar	Apr	May	Jun	Jul	Aug	Sep	Oct

FLORIDA AND TEXAS

OTHER STATES

HOST PLANT

NECTAR PLANTS

Passion vine	Butterfly bush	Egyptian starflower	Lantana

 p. 119

 p. 128

p. 133

 p. 128

Question Mark

(POLYGONIA INTERROGATIONIS)

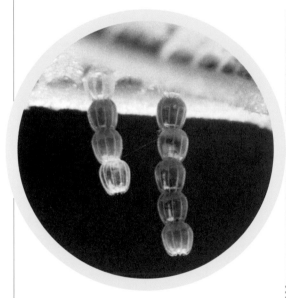

The Question Mark female may lay her eggs in stacks. See the empty "duds" on the top and bottom of the left-hand stack?

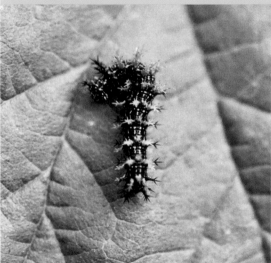

The caterpillar looks like the punctuation mark it's named for as it lies curled up on a leaf.

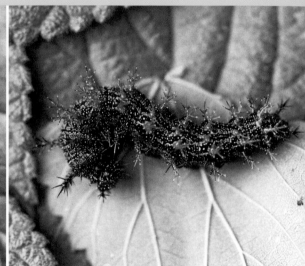

When mature, the caterpillar may have white dots and yellow or orange lines along its black body, as well as yellow or orange spines.

RAGGEDY, IRREGULARLY SPLOTCHED WINGS give the Question Mark a shabby look, and its love of fermented fruit and animal feces is difficult for humans to appreciate. But we like to watch these wary little butterflies, and they're often up and flying around on very chilly mornings, hours before any other butterflies appear.

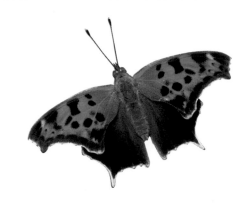

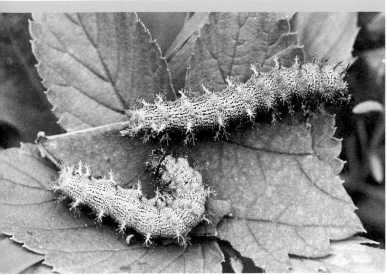

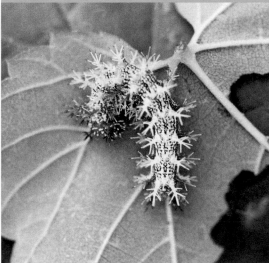

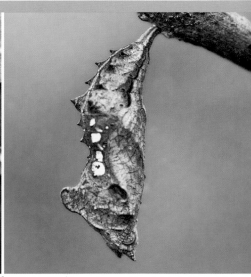

If it feels threatened, the caterpillar tends to curl up or drop to the ground to avoid predators. You can handle it safely, although it will feel prickly to the touch.

We've found that the coloration of Question Mark caterpillars varies widely. Some are black with orange spines; others, like the one shown here, have yellowish spines and areas of orange and black.

The chrysalis is subtle shades of tan or brown and has shiny metallic spots on the outward-facing side.

▶ When it is at rest, you can see the glowing ultraviolet edges of the Question Mark's wings. This butterfly is displaying the light-colored winter form. The summer form has very dark, almost black lower wings, with little or no pattern visible.

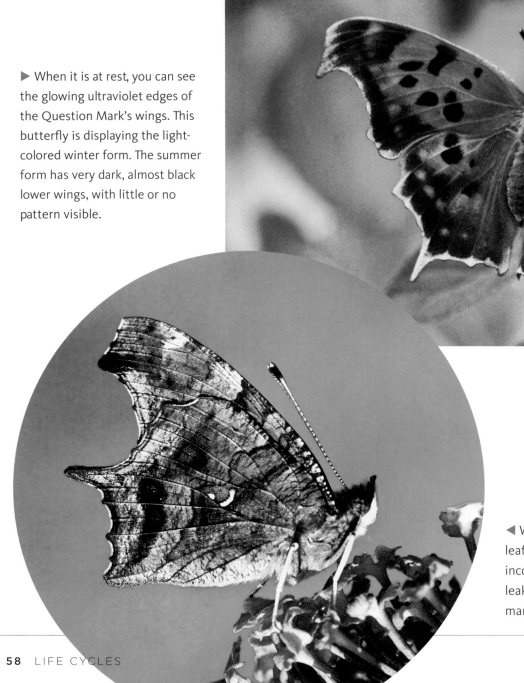

◀ Would you mistake this butterfly for a ragged old leaf? Its neutral-colored, mottled wings help it remain inconspicuous when perched on tree bark to drink leaking sap. Can you see the shiny silver question mark shape in the center of the wing?

Question Mark

* **Hungry Question Mark caterpillars** munch on our hop vines and on our elm and hackberry trees.

* **Most butterfly caterpillars spin white silk,** but the Question Mark caterpillar creates a pad of pink silk to anchor its chrysalis to a leaf or stem.

* **Question Marks emerge from their chrysalises** in the fall and spend the winter as inactive adults, hiding in woodpiles or under loose tree bark until spring.

* **The adult butterflies prefer** to sip juices from rotting fruit, tree sap, and animal droppings. Animal droppings contain proteins that nectar lacks.

* **Summer-flying adults** have dark, almost black hind wings. Adults flying in the fall have mostly orange-colored hind wings.

* **Look for the Question Mark** perching, as it often does, head down on the side of a tree trunk.

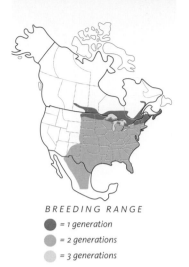

BREEDING RANGE

● = 1 generation
● = 2 generations
● = 3 generations

AVG. WINGSPAN = 2"

LIFE CYCLE SEASON

MAR	APR	MAY	JUN	JUL	AUG	SEP	OCT

HOST PLANTS

NECTAR PLANT

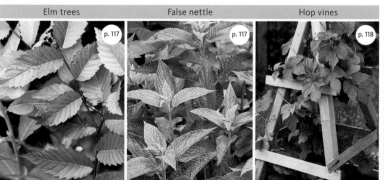

Elm trees	False nettle	Hop vines
p. 117	p. 117	p. 118

Butterfly bush
p. 128

Eastern Comma

(POLYGONIA COMMA)

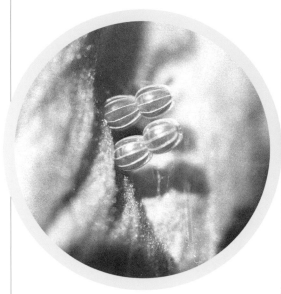

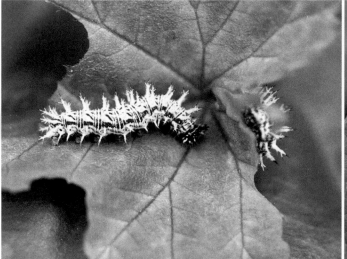

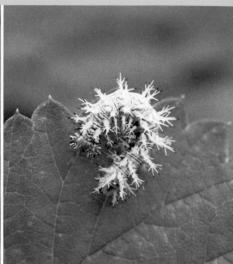

The Comma female lays her eggs on hop vines, elm trees, false nettle, and hackberry trees. Sometimes she stacks them together.

The growing caterpillar is covered with harmless white spines.

With every molt, the caterpillar's colors and spines look a bit different. Overall, though, it's still mostly white.

Here's a butterfly that isn't interested in our flowers! The Comma — also known in some places as the "hop merchant" because of the caterpillar's love of hop leaves — is drawn instead to mud, sap, and fruit. Its fast, erratic flight makes it difficult to catch.

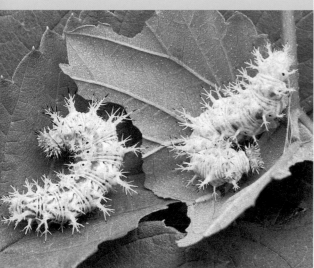

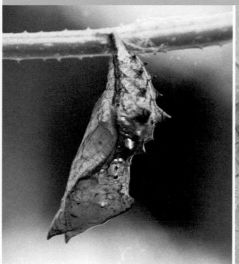

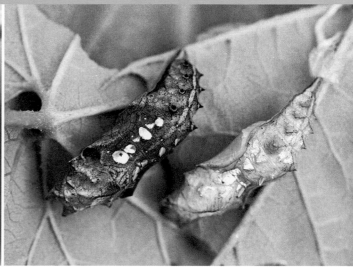

When the caterpillar feels threatened, it curls up and plays dead. It may even drop off the plant.

The chrysalis is shades of pale brown. It has several shiny silver spots that look as if they were painted on.

When you look at a Question Mark chrysalis (at left) and a Comma chrysalis side by side, you see how similar they are. The surest way to tell them apart is to notice the caterpillar before it pupates or to watch the butterfly emerge.

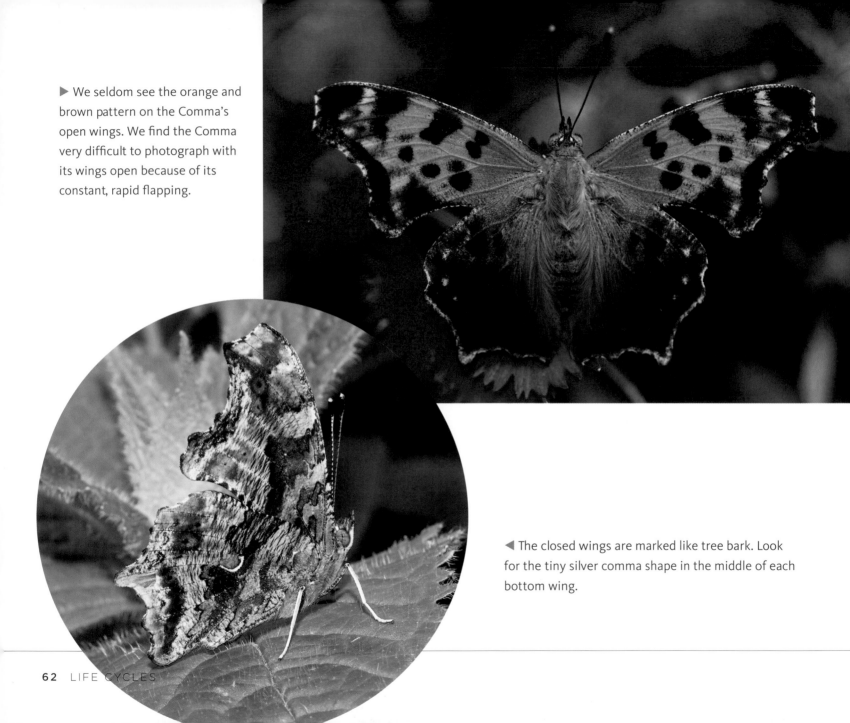

▶ We seldom see the orange and brown pattern on the Comma's open wings. We find the Comma very difficult to photograph with its wings open because of its constant, rapid flapping.

◀ The closed wings are marked like tree bark. Look for the tiny silver comma shape in the middle of each bottom wing.

Eastern Comma

* **Comma caterpillars may be small,** but they can eat a lot of hop leaves. They start by chewing the edges of the leaves and work their way gradually toward the center. They don't eat the hop's tough veins or stems, so the leaf skeleton is all that's left clinging to the vine when they've finished.

* **Smaller than the Question Mark butterfly,** the Comma comes out of hibernation a little earlier in the spring.

* **The Comma likes to lay its eggs** in hackberry trees. You shouldn't plant a hackberry tree in your yard unless you have plenty of open space. It can grow to be four stories tall!

* **A good place to look for Commas** in spring is a woodpile. The inactive adults sometimes spend the winter hiding there, emerging when the weather begins to warm up.

* **In the 19th century,** the metallic spots on a "hop merchant's" chrysalis were said to predict the year's hop prices: Gold spots forecast high prices and silver ones meant prices would be low.

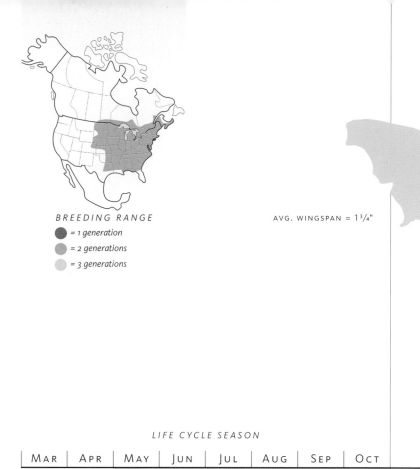

BREEDING RANGE

● = 1 generation
● = 2 generations
○ = 3 generations

AVG. WINGSPAN = 1¾"

LIFE CYCLE SEASON

| Mar | Apr | May | Jun | Jul | Aug | Sep | Oct |

HOST PLANTS

Elm trees	False nettle	Hop vines
p. 117	p. 117	p. 118

NECTAR PLANT

Butterfly bush
p. 128

Common Buckeye

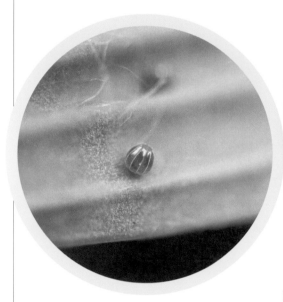

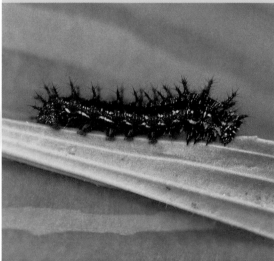

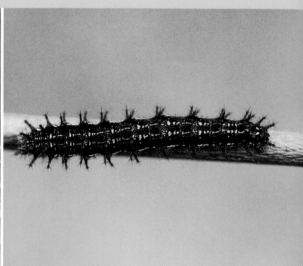

Buckeyes glue their eggs to the underside of plantain, toadflax, and snapdragon leaves.

The caterpillars eat large quantities of leaves and seem to grow faster when they eat plantain.

Most Buckeye caterpillars are dark colored, with bright blue dots at the base of each spine on their backs and broken yellow lines down the length of their bodies.

EVER HAVE THE FEELING YOU'RE BEING WATCHED? If there's a Buckeye around, multiply that by three! Those big eyespots fool some predators into thinking that the Buckeye is a force to be reckoned with. We like to watch these butterflies basking on a sunny patch of open earth or sipping from our stonecrop flowers.

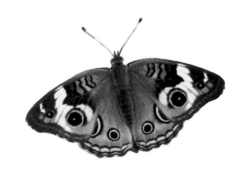

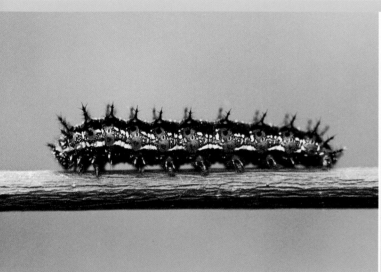

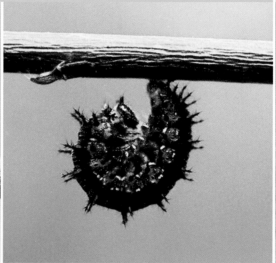

The Buckeye caterpillar has many fleshy feet that act almost like suction cups, helping the insect cling (even upside down) to twigs and plant stems.

This Buckeye caterpillar is hanging from a twig in preparation for shedding its skin and entering the chrysalis phase.

Each chrysalis has a unique color pattern. Notice the seam running down the left side. The chrysalis will split open there to release the butterfly.

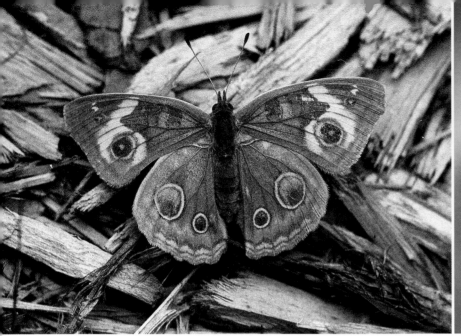

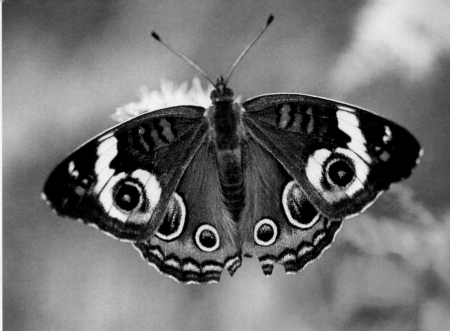

▲ (LEFT) Occasionally, when one of our Buckeyes emerges from its chrysalis, it displays this washed-out color (pale form). (RIGHT) Look at the beautiful iridescent eyespots on this dark form. The eyespots are defensive markings, making the Buckeye seem to be a larger creature.

◀ When closed, the Buckeye's wings have a pale cream and brown pattern that helps camouflage it.

Common Buckeye

* **Easily spooked,** Buckeye caterpillars will fall off their host plant to hide at the least sign of trouble.

* **Toadflax grows in the wild** and is a host to the Buckeye. Its flower looks like a snapdragon.

* **Buckeye butterflies often sit on bare ground** with their wings outstretched to soak up some sun. Males sometimes perch for hours at a time, waiting for a potential mate.

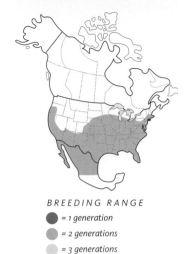

* **When disturbed,** Buckeyes fly rapidly, close to the ground, but often return to land in the same spot.

* **The distinctive eyespots** of the Buckeye make it relatively easy to identify.

* **If they don't fly south,** Buckeyes may die during our harsh winters in northern Kentucky. Once the cool days of October set in, we don't see them again until spring.

BREEDING RANGE

● = 1 generation
● = 2 generations
○ = 3 generations

AVG. WINGSPAN = 2"

LIFE CYCLE SEASON

| MAR | APR | MAY | JUN | JUL | AUG | SEP | OCT |

HOST PLANTS

NECTAR PLANTS

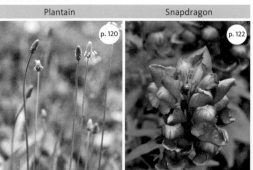

Plantain (p. 120)

Snapdragon (p. 122)

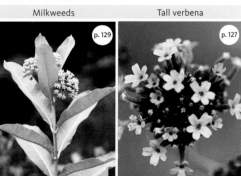

Milkweeds (p. 129)

Tall verbena (p. 127)

American Lady

(VANESSA VIRGINIENSIS)

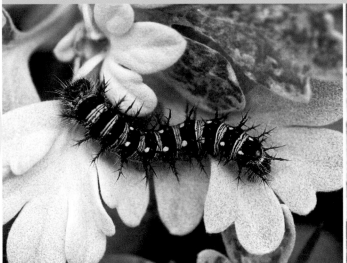

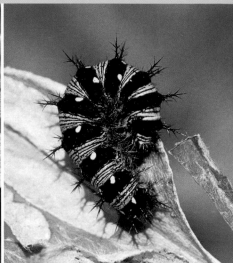

An American Lady female lays her eggs one at a time on pearly everlastings, artemisia, and plantain-leaved pussytoes.

The caterpillar is covered in many branched spines as well as dots and stripes along its entire body.

When it feels threatened, the caterpillar curls up and may drop straight to the ground in order to escape from danger.

QUICK AND WARY, THE AMERICAN LADY CAN BE very difficult to observe closely. With frantic darting movements, it eludes the curious gardener and even the stealthy photographer. The wings are quicker than the eye, and this Lady seems to fly sideways and even backward to escape observation.

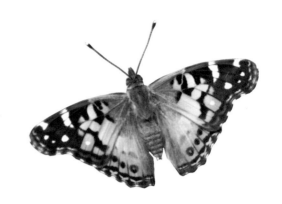

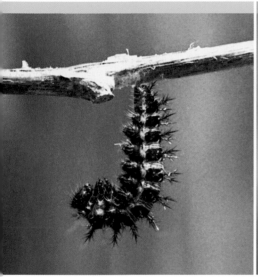

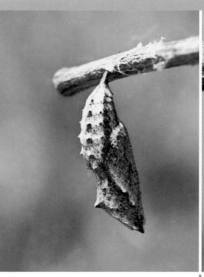

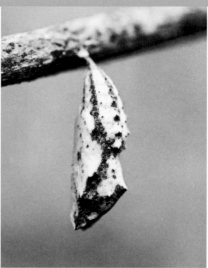

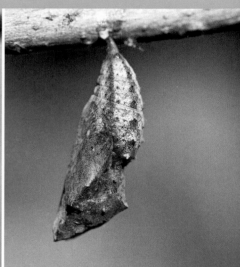

As many other caterpillars do, the American Lady hangs upside down in a J position to pupate.

Most of the chrysalises that we've seen are tan or brown and resemble a dead, dried-up leaf.

The less common chrysalis color variation is yellowish green with brown markings.

The chrysalis becomes thin and transparent, revealing the wing colors, before the butterfly is ready to emerge.

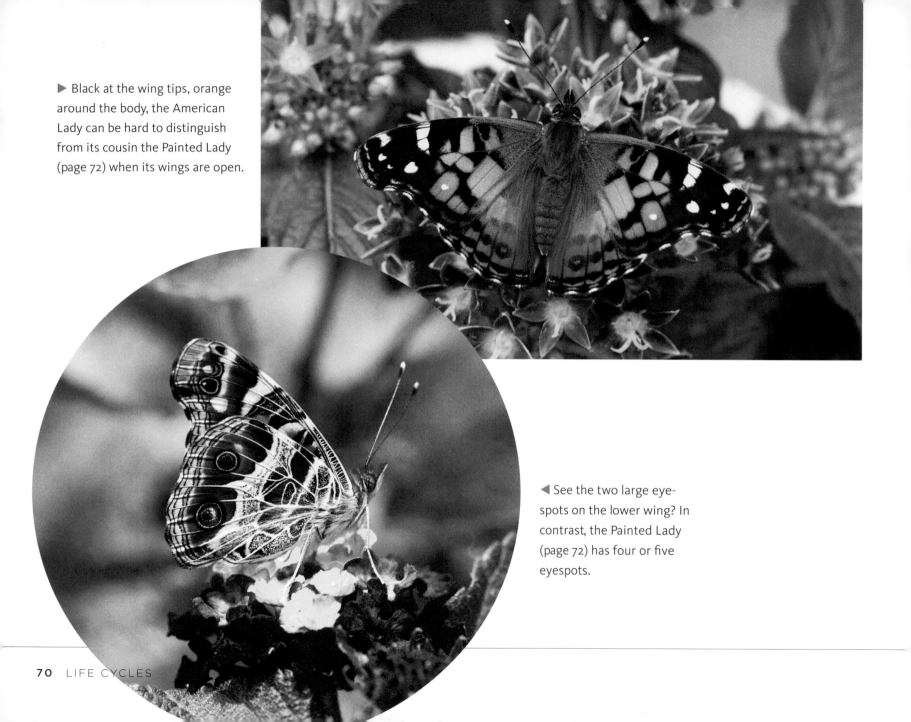

▶ Black at the wing tips, orange around the body, the American Lady can be hard to distinguish from its cousin the Painted Lady (page 72) when its wings are open.

◀ See the two large eye-spots on the lower wing? In contrast, the Painted Lady (page 72) has four or five eyespots.

American Lady

* **American Lady caterpillars make a silky nest** inside the leaves of their host plant, living in and feeding on them. If you see several leaves of everlastings stuck together, most likely there is a caterpillar inside.

* **Once the weather turns cold,** American Ladies disappear from our gardens and we don't see them again until spring.

* **American Ladies prefer** open areas and low-growing host and nectar plants.

* **When its wings are open,** this butterfly shows one white spot floating inside a square orange patch on each of the top wings. The Painted Lady does not have this mark.

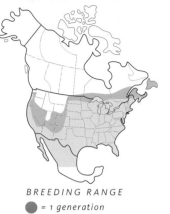

BREEDING RANGE

● = *1 generation*

● = *2 generations*

○ = *3 generations*

AVG. WINGSPAN = 2¼"

LIFE CYCLE SEASON

MAR	APR	MAY	JUN	JUL	AUG	SEP	OCT

HOST PLANTS

Artemisia	Pearly everlasting	Plantain-leaved pussytoes

p. 116 p. 121

NECTAR PLANTS

Coneflowers	Tall verbena

p. 127 p. 127

Painted Lady

(VANESSA CARDUI)

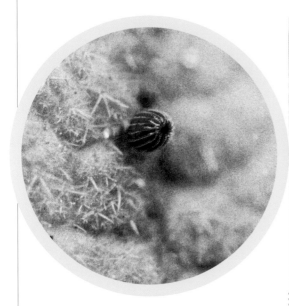

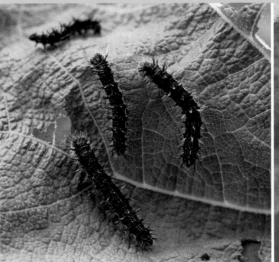

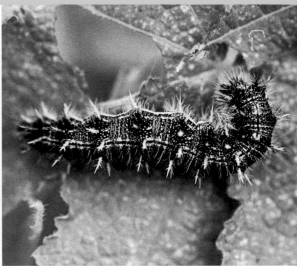

The Painted Lady female lays her eggs one at a time on the top surfaces of leaves. The eggs are a lovely blue or green and have ridges all around.

The caterpillars don't seem to mind eating together as a group. As they munch, they spin loose webs of silk around the leaves, which help hide them from predators.

The fully grown caterpillar is mostly black and has lots of pale hairs and branched spines.

THE LOVELY PAINTED LADY IS A REGULAR VISITOR to our flower gardens. This dappled beauty makes frequent stops to sip nectar or to tease us by perching on a shoulder or hat brim. The playful antics of this social butterfly add a bit of fun to a hot day of gardening.

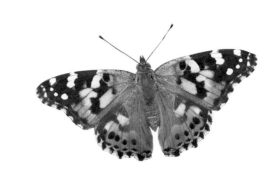

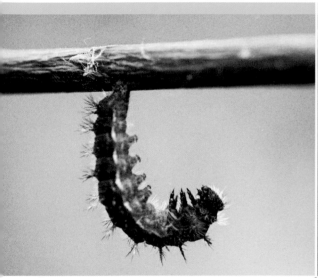

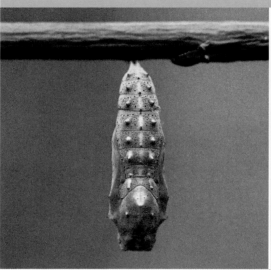

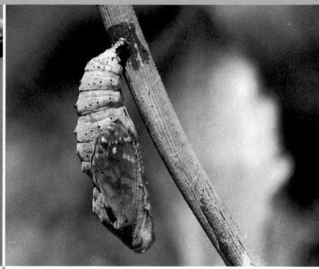

When it is time to pupate, the caterpillar hangs upside down from a twig or plant stem and sheds its skin one last time.

The tan chrysalis is covered in shiny gold dots that make it look more like a piece of jewelry than an insect.

The orange wing markings are visible through this chrysalis. The butterfly will be ready for *eclosion* (emergence) soon.

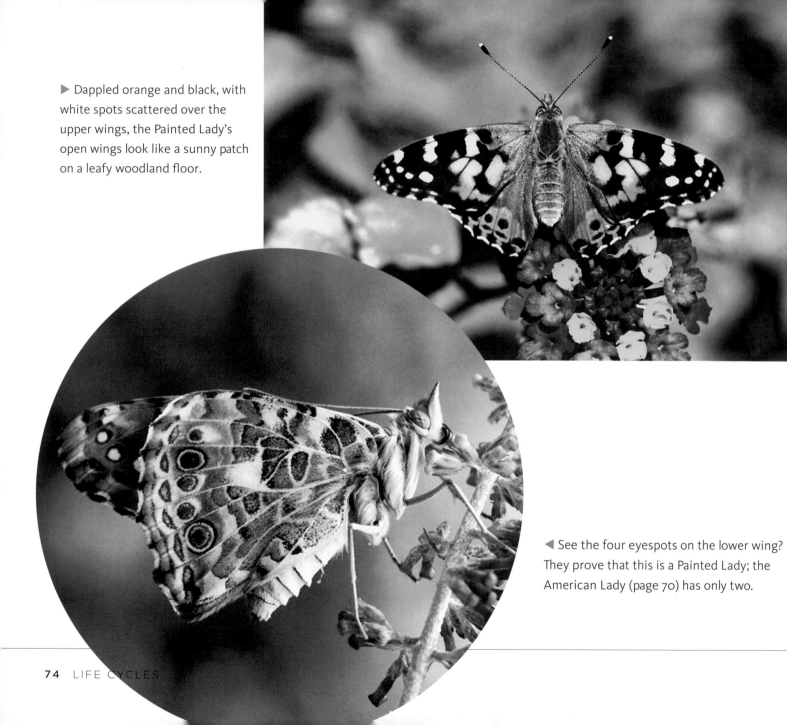

▶ Dappled orange and black, with white spots scattered over the upper wings, the Painted Lady's open wings look like a sunny patch on a leafy woodland floor.

◀ See the four eyespots on the lower wing? They prove that this is a Painted Lady; the American Lady (page 70) has only two.

Painted Lady

* **Professional breeders and schools** often choose to raise Painted Lady caterpillars because they can be fed an artificial diet. This saves them the trouble of growing particular host plants and makes the Painted Lady easy to rear.

* **Because its favorite host plant is wild thistle,** the Painted Lady used to be called the Thistle Butterfly. Their world-wide presence has allowed the Painted Lady to take up residence throughout North America, Asia, Africa, and Europe. We don't suggest planting thistle in your garden, however, because it can irritate your skin and tends to be invasive.

* **In autumn Painted Ladies fly south** because they can't survive the harsh winter weather up north. We see them in our yards in their greatest numbers in September.

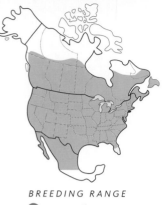

BREEDING RANGE

● = *1 generation*
● = *2 generations*
● = *3 generations*

AVG. WINGSPAN = 2 ½"

LIFE CYCLE SEASON

| MAR | APR | MAY | JUN | JUL | AUG | SEP | OCT |

HOST PLANTS

| Hollyhocks | Thistle |

NECTAR PLANTS

| Coneflowers | Tall verbena |

p. 118

p. 127

p. 127

Red Admiral

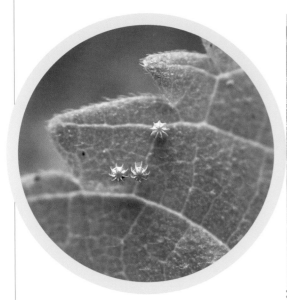

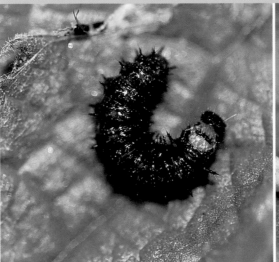

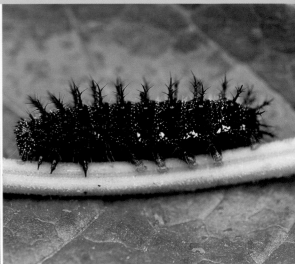

Red Admirals lay their green, barrel-like eggs on the topmost tender leaves of their host plants. These eggs have been laid on a false nettle.

Tiny at first, the blackish caterpillar has a black head covered in hairs.

As the caterpillar grows, it develops many branched spines that may help protect it from predators.

LOVERS OF ROTTING FRUIT AND TREE SAP, Red Admirals are sociable and easy to spot: They look as if someone painted a bright red-orange semi-circle on each of their open wings. They fly with a quick, darting habit and are fond of the coneflowers in our gardens.

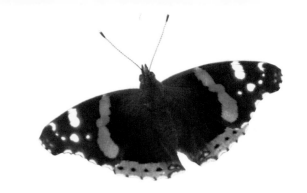

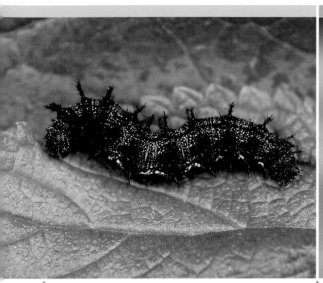

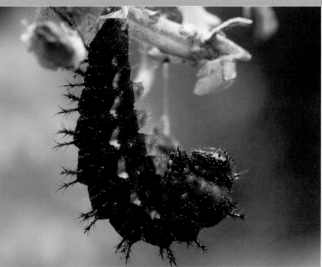

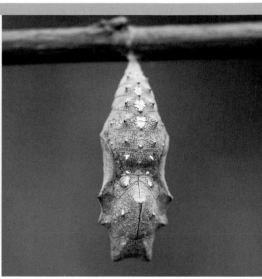

More-mature caterpillars may have orange spots around their spines. You may also find caterpillars that show patterns of white or yellow.

Unlike those species that wander far away, the Red Admiral caterpillar may stay on its host plant until it becomes a butterfly. When it is fully grown and ready to enter the chrysalis phase, the caterpillar hangs upside down to shed its skin.

The chrysalis can be various shades of brown or gray, decorated with shiny metallic gold spots.

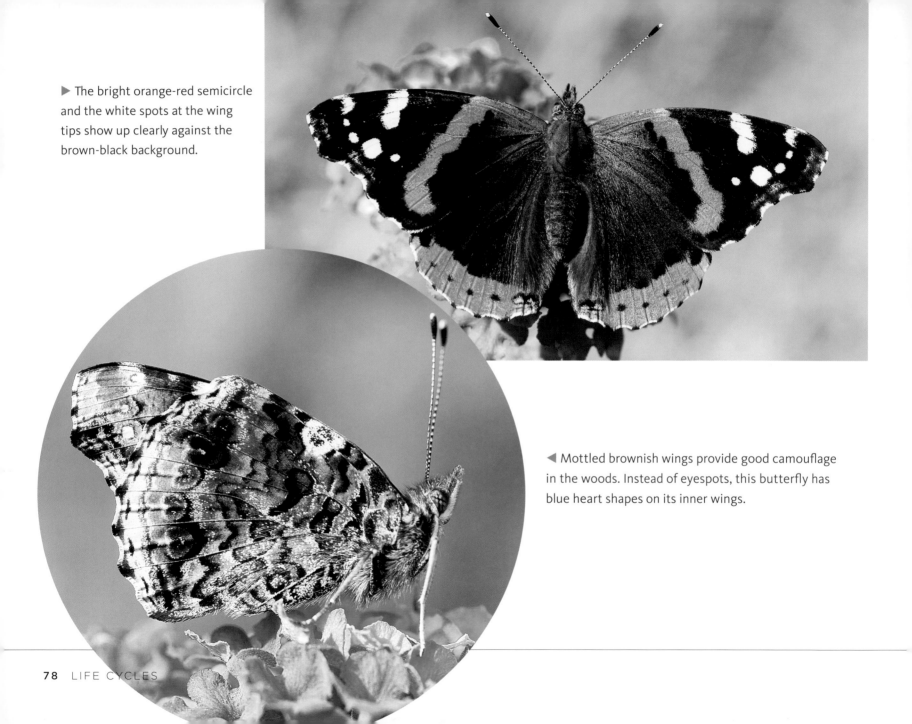

▶ The bright orange-red semicircle and the white spots at the wing tips show up clearly against the brown-black background.

◀ Mottled brownish wings provide good camouflage in the woods. Instead of eyespots, this butterfly has blue heart shapes on its inner wings.

Red Admiral

✳ **The caterpillar may spin** silk threads onto a host plant's leaf, folding it over to create a tent to hide in.

✳ **Adult butterflies drink** flower nectar but prefer to sip rotting fruit juices and tree sap. If the rotting fruit has fermented, the butterflies can get drunk!

✳ **Because they crave salt** in human sweat, don't be surprised to find a Red Admiral sitting on your shoulder in the garden.

✳ **Red Admirals fly south,** sometimes in large numbers, when the weather starts to cool down in the fall. In the spring they wander back to the northern states looking for food.

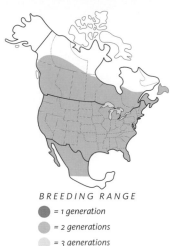

BREEDING RANGE

AVG. WINGSPAN = 2 ½"

- = 1 generation
- = 2 generations
- = 3 generations

LIFE CYCLE SEASON

MAR	APR	MAY	JUN	JUL	AUG	SEP	OCT

HOST PLANTS

False nettle	Pellitory

p. 117

NECTAR PLANTS

Butterfly bush	Coneflowers

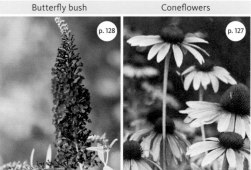

p. 128 · p. 127

Red Admiral **79**

Silvery Checkerspot

(CHLOSYNE NYCTEIS)

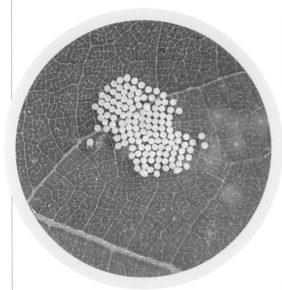

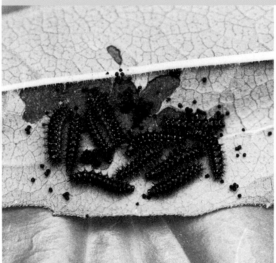

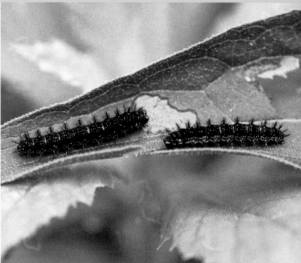

The Silvery Checkerspot female lays her cream-colored eggs in clusters under the leaves of our purple coneflowers.

After hatching, the caterpillars remain together, eating as a group until they pupate. They scrape the leaf surface, leaving behind a "skeleton" of stems and veins.

Don't let their small size fool you. These caterpillars will devour a lot of coneflower leaves in just a few days. They don't eat the flowers, though, so we still have blooms to enjoy.

LOOK FOR THE SILVERY CHECKERSPOT IN MOIST WOODLANDS: It has a fondness for small streams and creek beds. On the move, it darts quickly and erratically, close to the ground. When it perches, it keeps its wings wide open. The males of the species like to gather around animal droppings or in areas where there's plenty of damp soil.

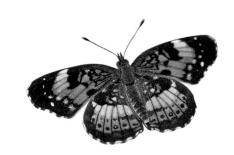

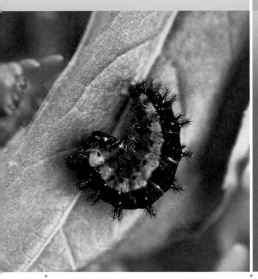

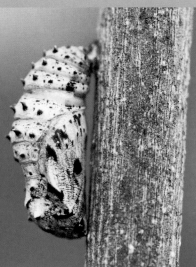

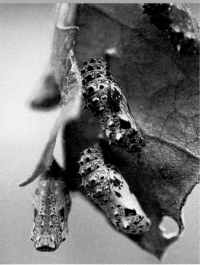

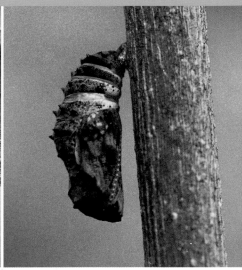

The caterpillars spin a patch of silk to hang from, and then assume this J position to prepare for the chrysalis phase.

The chrysalis is shades of cream and brown with several rows of short spikes. The earthy colors make it difficult to spot among our garden plants.

These siblings formed their chrysalises together. When disturbed, they'll twitch and jump around.

You can tell from the way the wing colors show through the chrysalis that this butterfly is ready to break free and cling to a plant to let its wings dry.

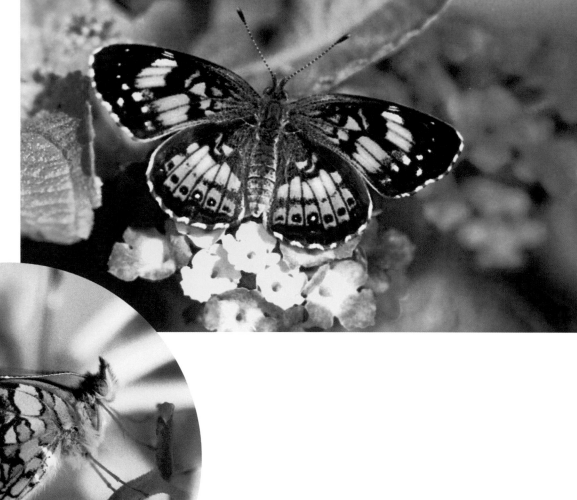

▶ The tiny white circles toward the bottom of the Checkerspot's lower wings are different from the similarly placed solid black dots of its close relative, the Pearl Crescent (page 111).

◀ The pale silvery spots checkered on the underside of its wing give this butterfly its name.

Silvery Checkerspot

* **Caterpillars of this species that hatch in late summer** will not grow to their full size in one season, but instead will spend the winter hibernating at the base of the host plant. They won't wake up to feed and mature until spring.

* **Be careful during fall garden cleanup:** Young Silvery Checkerspot caterpillars may be hibernating at the base of your coneflowers for the winter. Don't disturb them!

* **This small butterfly's flight** is fast and erratic. It is a bit larger than the Pearl Crescent (page 111).

* **The female is larger than the male** and glides low to the ground when a male pursues her.

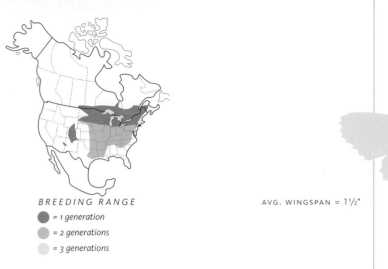

BREEDING RANGE

● = 1 generation
● = 2 generations
● = 3 generations

AVG. WINGSPAN = 1½"

LIFE CYCLE SEASON

| MAR | APR | MAY | JUN | JUL | AUG | SEP | OCT |

HOST PLANTS NECTAR PLANTS

Coneflowers — p. 116

Cosmos — p. 132

Sunflower — p. 131

Tall verbena — p. 127

Red-spotted Purple

(LIMENITIS ARTHEMIS ASTYANAX)

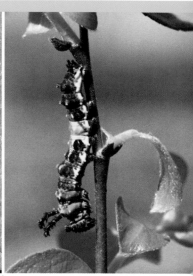

The Red-spotted Purple female lays a single egg at the very tip of the leaf. Each egg is covered in dimples like a golf ball.

When the caterpillars are young, they eat the tip of the leaf and often leave the tough vein intact.

When the caterpillar is disturbed, it curls up, lies very still, and looks like a bird dropping.

The caterpillar, which develops lumpy skin and prickly antennae, may be shades of tan, cream, or brown.

ALTHOUGH IT DOESN'T HAVE LONG TAILS, the Red-spotted Purple closely resembles the bad-tasting Pipevine Swallowtail (page 29), and most birds avoid it. We appreciate its beautiful, relaxed flying habit and its amazing iridescence. Because the Red-spotted Purple prefers woodlands, we consider its appearance among our garden flowers a rare treat.

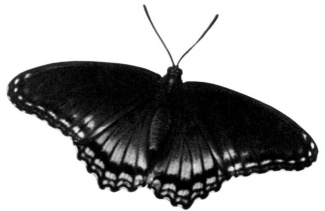

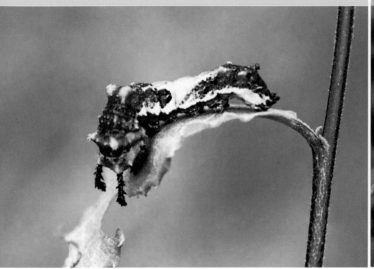

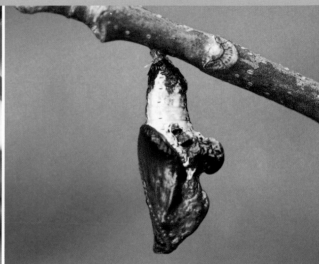

This Red-spotted Purple caterpillar is resting on a willow leaf.

Caterpillars born in late summer stop growing after about a week. They use silk to roll up a leaf to hibernate in until spring arrives.

The Red-spotted Purple's chrysalis is the same drab colors as the caterpillar. It blends in well among stems and branches in the garden.

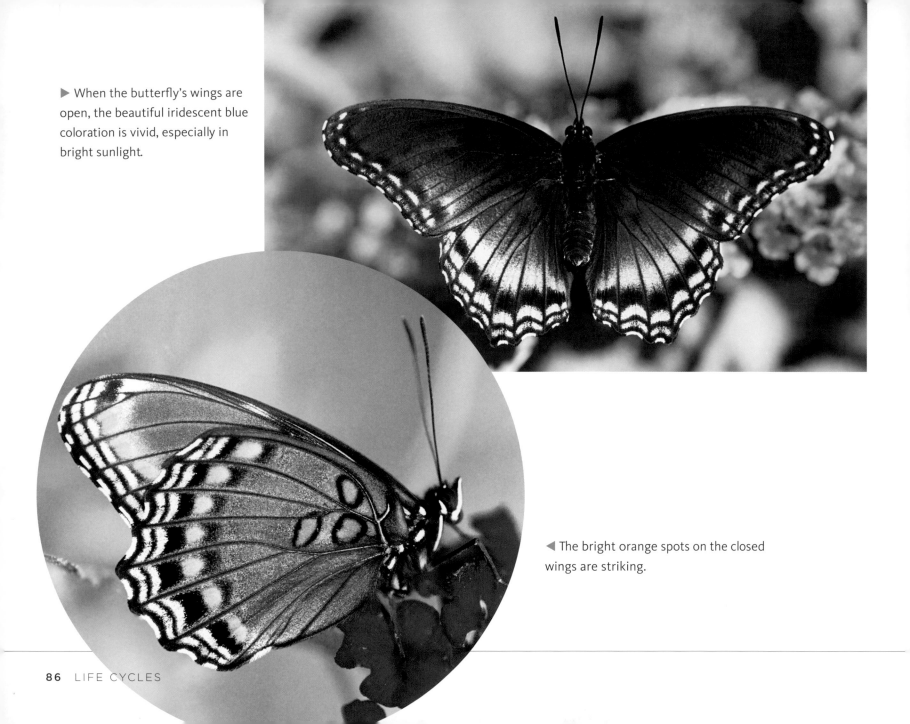

▶ When the butterfly's wings are open, the beautiful iridescent blue coloration is vivid, especially in bright sunlight.

◀ The bright orange spots on the closed wings are striking.

Red-spotted Purple

✳ **Red-spotted Purple caterpillars** and their chrysalises are very similar to Viceroy caterpillars and their chrysalises.

✳ **We see these butterflies only one at a time,** usually when a female is laying her eggs on our various willows.

✳ **These butterflies like to sip juices** from rotting fruit. They're one of the most frequent visitors to our rotting-fruit trays. They also feed on carrion, sap, and animal droppings.

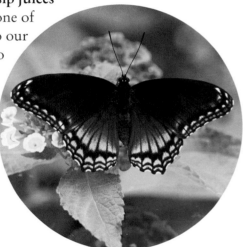

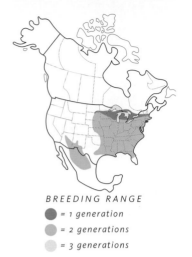

BREEDING RANGE

● = 1 generation
● = 2 generations
● = 3 generations

AVG. WINGSPAN = 3"

LIFE CYCLE SEASON

| MAR | APR | MAY | JUN | JUL | AUG | SEP | OCT |

HOST PLANTS *NECTAR PLANTS*

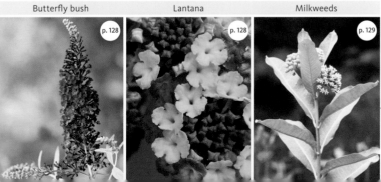

| Willows | Butterfly bush | Lantana | Milkweeds |
| p. 125 | p. 128 | p. 128 | p. 129 |

Viceroy

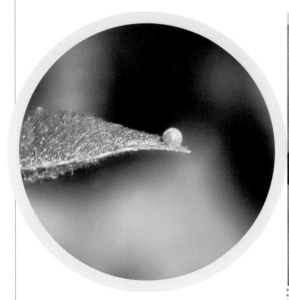

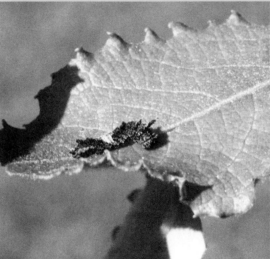

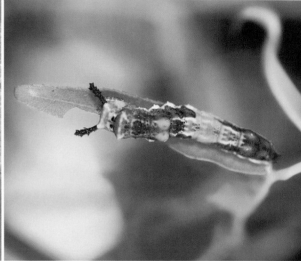

The Viceroy female lays a single egg at the very tip of a leaf of the host plant. This may make it harder for predators to find.

The baby caterpillar is brown with a white saddle. Find one by looking for chewed leaf tips in trees.

If born in early summer, the caterpillar continues to grow. It often looks just like a Red-spotted Purple caterpillar (page 84), but may be olive-colored instead of brown.

VICEROY, MONARCH, OR QUEEN? If you have only a few seconds to decide, look at the lower wing: A thick black line loops across only the Viceroy's. The Viceroy flaps its wings a little less often than do the others, pausing to glide from time to time. It'll pause to sip too, with its wings half open, on our sweet william, coneflowers, or lantana.

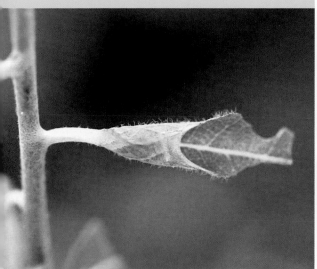

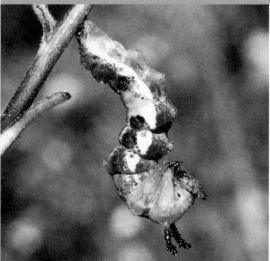

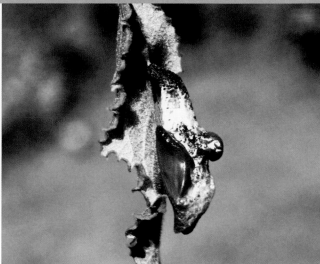

In colder regions a caterpillar born in the fall makes a leaf tube, called a *hibernaculum,* as a hiding place to spend the winter months.

In the hot summer months, when the caterpillar is ready to pupate, it hangs upside down from a branch and undergoes its final molt to reveal the chrysalis.

The chrysalis of the Viceroy looks the same as that of the very closely related Red-spotted Purple (page 85).

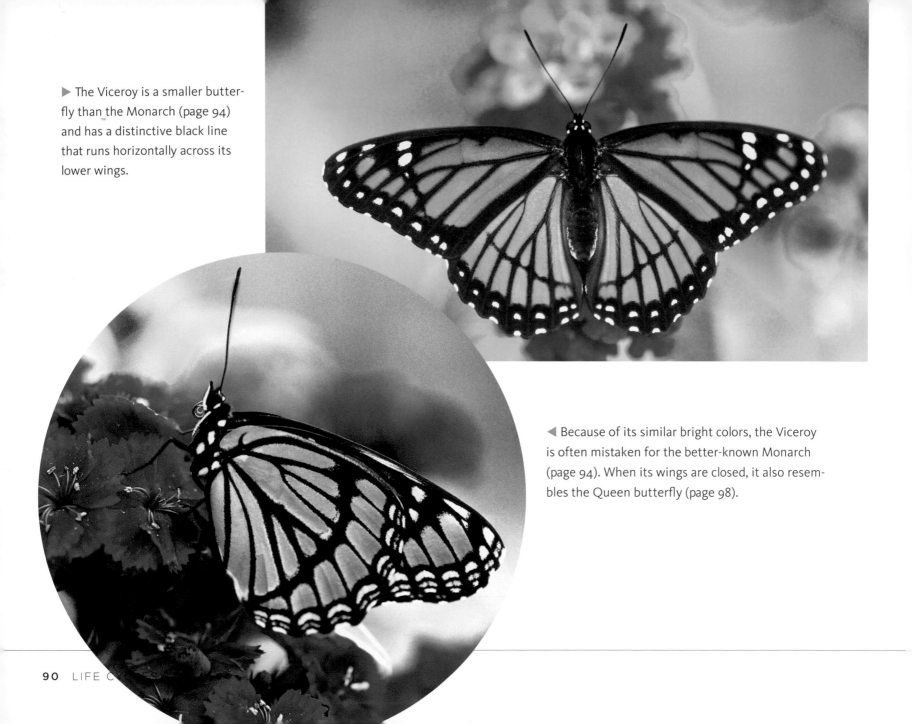

▶ The Viceroy is a smaller butterfly than the Monarch (page 94) and has a distinctive black line that runs horizontally across its lower wings.

◀ Because of its similar bright colors, the Viceroy is often mistaken for the better-known Monarch (page 94). When its wings are closed, it also resembles the Queen butterfly (page 98).

Viceroy

* **Viceroy caterpillars look like bird droppings,** as do Red-spotted Purple caterpillars (page 84). This may slow down their predators somewhat.

* **Birds avoid the Viceroy** butterfly because it looks so much like the bad-tasting Monarch. Recent research suggests, however, that the Viceroy also tastes bad.

* **Willows are hardy** and available in many varieties and leaf shapes. We have corkscrew willow and dwarf blue leaf arctic willow in our gardens, and Viceroys lay eggs on both.

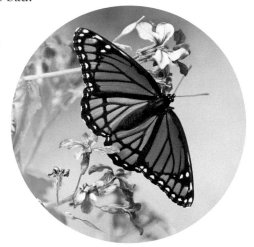

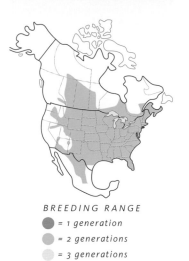

BREEDING RANGE

● = *1 generation*
● = *2 generations*
○ = *3 generations*

AVG. WINGSPAN = 3"

LIFE CYCLE SEASON

| MAR | APR | MAY | JUN | JUL | AUG | SEP | OCT |

HOST PLANTS

Willows

p. 125

NECTAR PLANTS

Butterfly bush

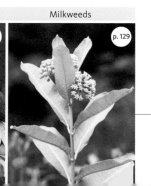

p. 128

Coneflowers

p. 127

Milkweeds

p. 129

Monarch

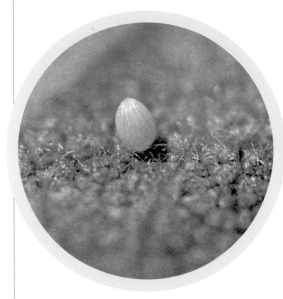

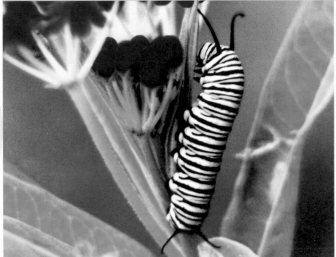

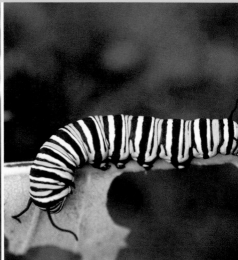

We usually find a single egg under a host milkweed leaf. We've sometimes found them on milkweed flowers and seedpods.

The bright stripes warn predators that this caterpillar is not a tasty meal.

After it hatches, the caterpillar eats the m weed's leaves. The plant's toxic glycosides are absorbed into the caterpillar's body, a do not hurt it.

PROBABLY THE MOST RECOGNIZED, most studied butterfly in North America, the Monarch is loved and watched by children and adults alike. Who can help but be attracted to the bright striped caterpillar and glittering green chrysalis that eventually become this orange and black beauty?

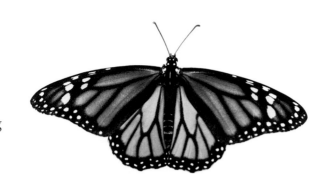

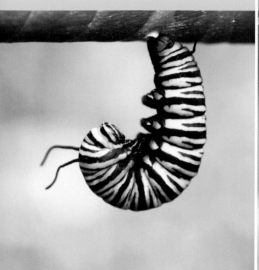

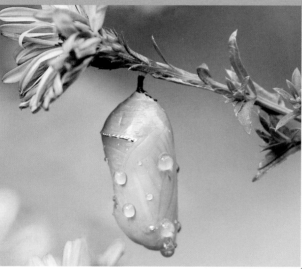

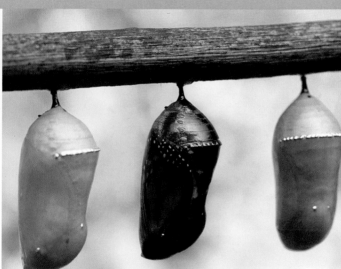

When the caterpillar is ready for the next phase, it hangs upside down from a patch of silk that it has spun.

The pale green chrysalis is adorned with shiny golden dots. The chrysalis matches the color of plant leaves.

Just before the butterfly emerges, the chrysalis becomes transparent and the wings can be seen.

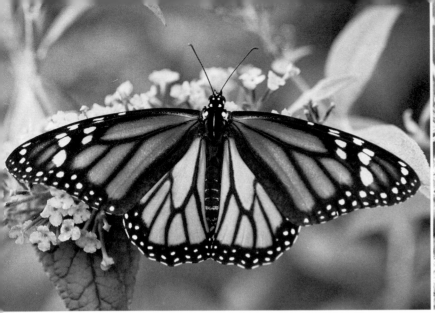

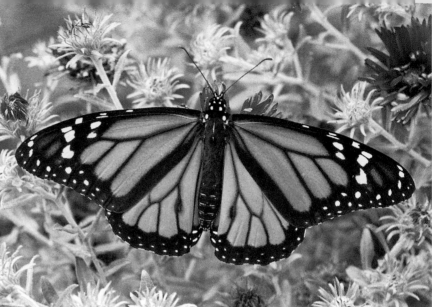

▲ The Monarch's wing veins, deep black against a burnt orange background, are visible whether the wings are open or closed. Large and small white dots are sprinkled around the edges of the wings and all over the Monarch's black body.

▲ Males have scent glands on their lower wings that produce pheromones for mating; they appear as small black spots on the wing veins.

◄ The Monarch's orange color is more subtle when the wings are closed. Don't mistake this butterfly for its similarly colored cousin, the Viceroy (page 90): The Monarch is larger.

Monarch

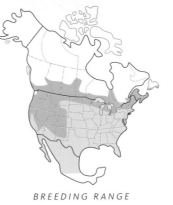

* **Four black filaments** adorn the caterpillar's body.

* **Monarch caterpillars absorb toxins** from milkweed plants into their bodies. The toxins will sicken birds, lizards, and mammals, but predators like wasps and spiders are immune to them.

* **The green chrysalis** of the Monarch looks almost identical to that of the Queen butterfly (page 97).

* **The only butterfly that migrates north and south every year** is the Monarch, although no single Monarch makes the trip in both directions.

* **Host plants for the Monarch** are those belonging to the Milkweed family. The wild milkweeds do not transplant well and should be collected only as seedpods in the fall.

* **An organization called Monarch Watch** tags Monarchs before they migrate so they can be tracked when they reach Mexico.

BREEDING RANGE

● = 1 generation
● = 2 generations
○ = 3 generations

AVG. WINGSPAN = 4"

LIFE CYCLE SEASON

MAR	APR	MAY	JUN	JUL	AUG	SEP	OCT

HOST PLANTS

NECTAR PLANT

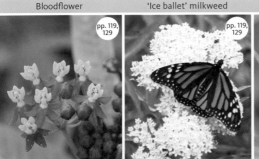

Bloodflower	'Ice ballet' milkweed	Pink swamp milkweed	Wild milkweed	Orange butterfly weed
pp. 119, 129	pp. 119, 129	pp. 119, 129	p. 119	p. 129

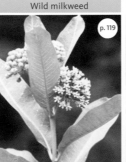

Queen

(DANAUS GILIPPUS)

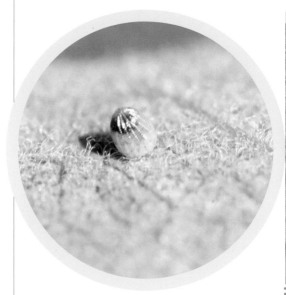

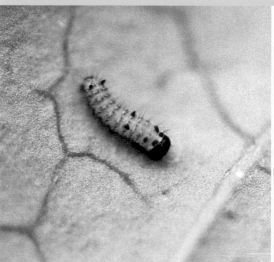

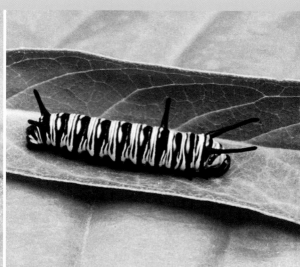

You can find oval cream-colored Queen eggs on the underside of milkweed leaves. The eggs gradually become transparent; here you can see the caterpillar's dark head getting ready to chew its way out of the egg.

This is a newly hatched Queen caterpillar. It eats its own eggshell as soon as it hatches and then looks for a tender leaf.

Like its cousin the Monarch (page 92), the Queen depends on milkweed as its host plant, and it stores the plant toxins in its body for self-defense.

THIS COUSIN OF THE MONARCH ROYAL FAMILY is somewhat less showy, especially when you see its simply patterned wings wide open, from above. When it is flying energetically from one milkweed flower to the next, you might have to look carefully to tell the Monarch from the Queen.

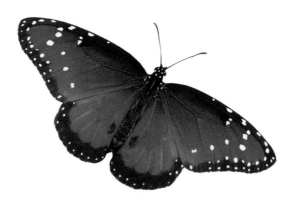

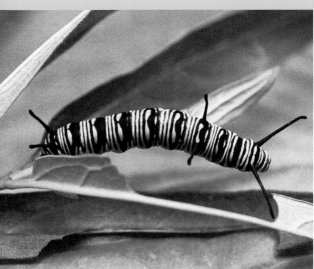

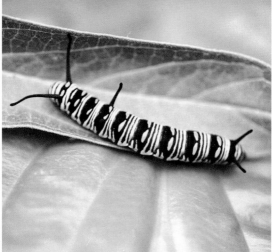

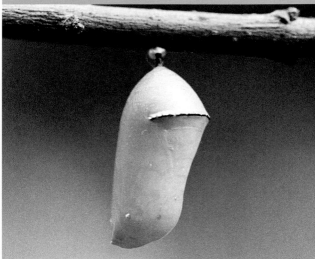

The color and the appearance of the Queen don't change much with each molt. Notice the caterpillar's six black filaments sticking up from its body. Monarchs have just four.

Is this caterpillar coming or going? Maybe predators can't tell either, since there seem to be antennae on both ends.

Here you can see that the green chrysalis of the Queen looks almost identical to that of the Monarch (page 93).

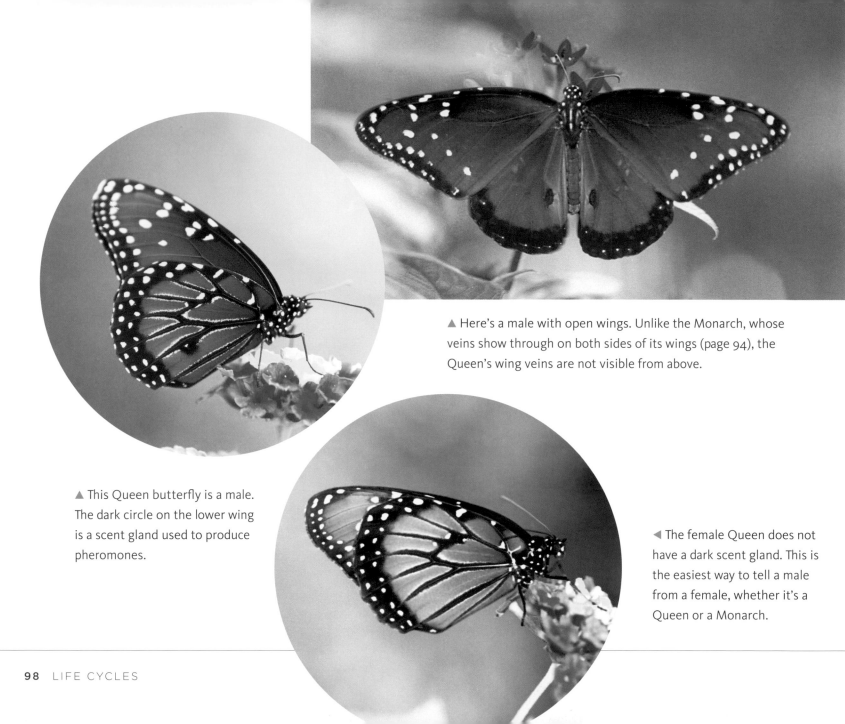

▲ Here's a male with open wings. Unlike the Monarch, whose veins show through on both sides of its wings (page 94), the Queen's wing veins are not visible from above.

▲ This Queen butterfly is a male. The dark circle on the lower wing is a scent gland used to produce pheromones.

◄ The female Queen does not have a dark scent gland. This is the easiest way to tell a male from a female, whether it's a Queen or a Monarch.

Queen

* **Queen caterpillars** make no attempt to hide. They store milkweed plant toxins in their bodies, and predators have learned to avoid them.

* **Voracious eaters,** the caterpillars steadily devour every part of the milkweed host plant except the roots and tough stems.

* **A year-round resident of Florida,** the Queen seldom wanders very far northward, but is often released into butterfly conservatories for public viewing.

* **The easiest way to distinguish the Queen** from its Monarch cousin when in flight is by its darker color. The Queen is almost brown instead of orange.

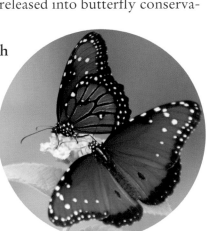

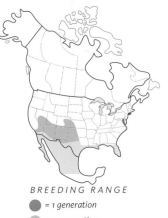

BREEDING RANGE

● = 1 generation
● = 2 generations
○ = 3 generations

AVG. WINGSPAN = 4"

LIFE CYCLE SEASON

MAR	APR	MAY	JUN	JUL	AUG	SEP	OCT

FLORIDA AND MEXICO
OTHER STATES

HOST PLANTS

NECTAR PLANTS

Milkweeds	Butterfly bush	Lantana	Zinnia

p. 119

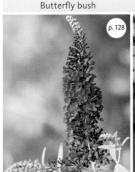

p. 128

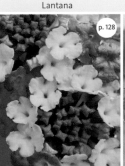

p. 128

p. 131

Cabbage White

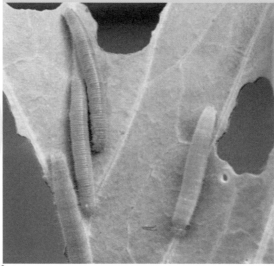

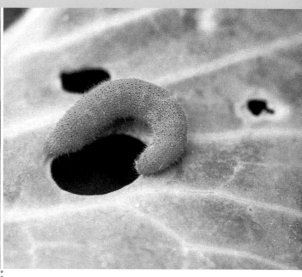

Cabbage White butterflies lay their eggs on — you guessed it! — cabbage plants. They will also lay their eggs on nasturtiums and spider flowers.

Because the Cabbage White lays so many eggs at one time, its large broods of caterpillars quickly devour any host plant.

The small green caterpillars love nasturtiums and plants in the Mustard family. They also eat spider flower (*Cleome*) leaves.

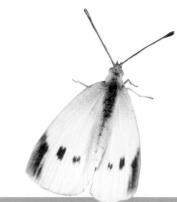

CABBAGE WHITES, WHICH SPEND A GREAT DEAL OF TIME chasing each other through our yards, look like bits of paper fluttering around. We often have more than 20 of them at a time, dancing a graceful aerial ballet.

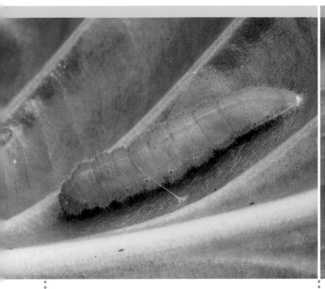

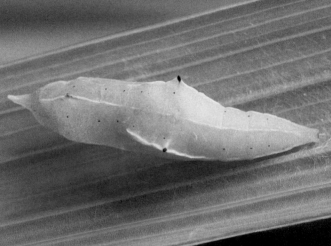

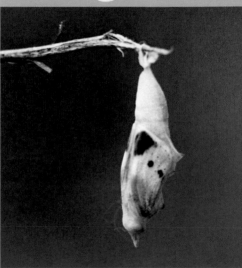

Cabbage White caterpillars often attach themselves to a leaf to pupate. Can you see the tiny silk pad at the rear and the thin thread of silk at this caterpillar's middle?

The chrysalises are green or tan. We often find one hanging right on its host plant. They spend the cold winter months in chrysalis form, waiting for warmer spring days as a signal to emerge.

The silk-thread harness has broken and the butterfly is moments from breaking free.

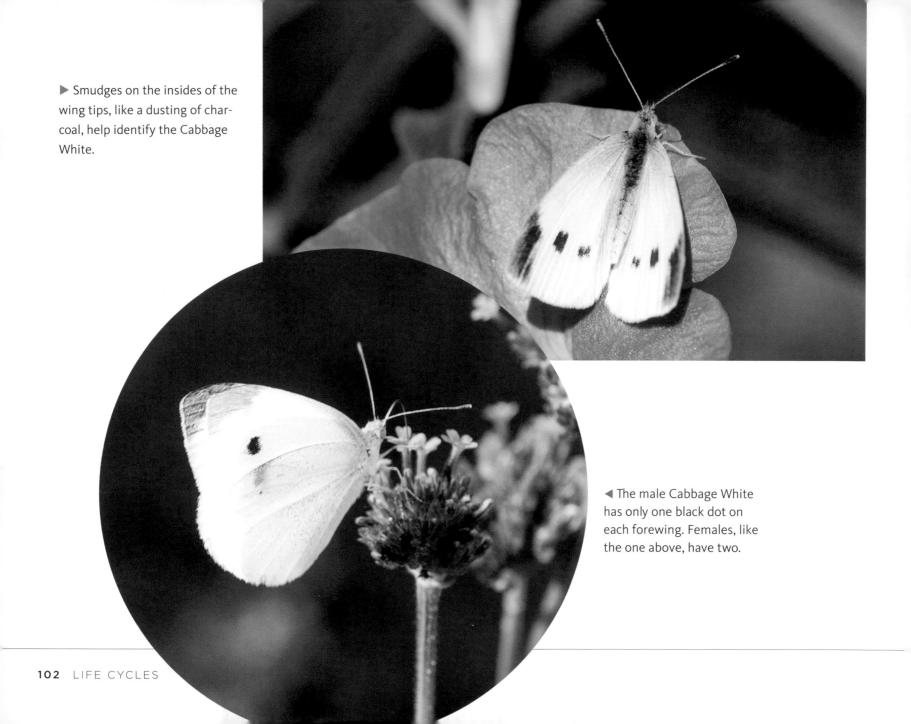

► Smudges on the insides of the wing tips, like a dusting of charcoal, help identify the Cabbage White.

◄ The male Cabbage White has only one black dot on each forewing. Females, like the one above, have two.

Cabbage White

✳ **Farmers are not thrilled** with the Cabbage White caterpillar; they consider it an agricultural pest.

✳ **Although not native** to North America, the Cabbage White has made itself at home here and flourished. You can find this butterfly almost anywhere.

✳ **Although cabbage is a main host** for the Cabbage White, we prefer to plant pretty spider flowers in our garden. The cabbage tends to stink after a while.

✳ **One of the reasons we enjoy this butterfly** is that it's easy to approach. It's not as jumpy and nervous as are some other types of butterflies.

✳ **Cabbage Whites continue to mate** and lay eggs until the first frost.

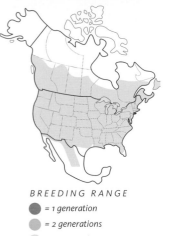

BREEDING RANGE

⬤ = 1 generation
⬤ = 2 generations
⬤ = 3 generations

AVG. WINGSPAN = 1 ½"

LIFE CYCLE SEASON

MAR	APR	MAY	JUN	JUL	AUG	SEP	OCT

HOST PLANTS

NECTAR PLANTS

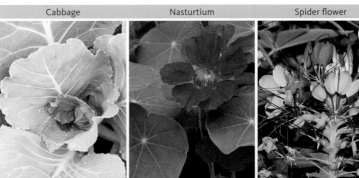

| Cabbage | Nasturtium | Spider flower |

p. 123

| Cosmos | Tall verbena |

p. 132 p. 127

Clouded Sulphur

(COLIAS PHILODICE)

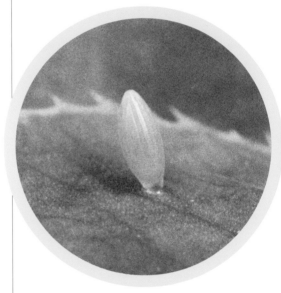

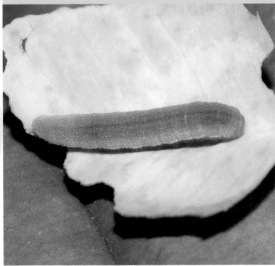

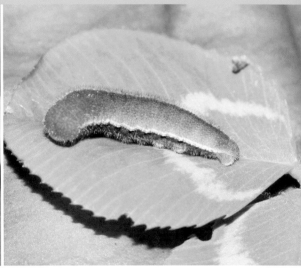

Sulphur butterflies lay their tiny eggs on clover leaves. At first the eggs are white, then become cream or pale yellow, and finally turn red before the caterpillars hatch.

The bright green caterpillar is almost invisible to the casual observer, because it likes to lie along the middle vein of the leaf.

This small species grows to be only about an inch long. You could have a lawn full of them and not even know it.

ALMOST CONSTANTLY IN MOTION, the Sulphur creates a familiar patch of fluttering yellow anywhere there are open fields or parks. We like to plant areas of clover especially for Sulphurs, and watch their quick flight just above the level of the flowers.

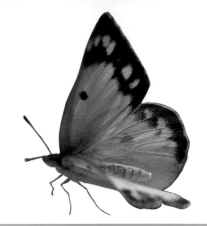

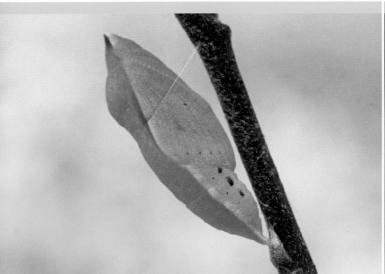

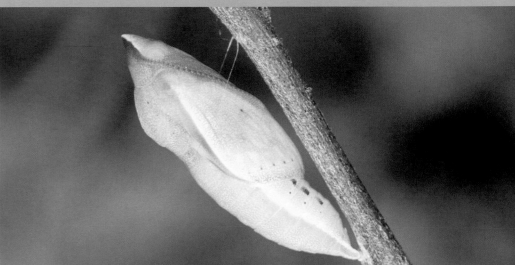

The pale green chrysalis is suspended from a twig by a thin silk thread; it is also attached by a patch of silk at the rear end. At this stage you could easily mistake the chrysalis for a leaf.

Before the butterfly emerges, its chrysalis takes on a pink tint and the wing pattern inside becomes visible. See the dark pink "zipper" at the top? This section splits open to allow the butterfly to crawl out.

▶ The open wings are bright yellow with black trim and each sports a black dot. Females, like the one shown here, have yellow dots in the top black wing margin; males do not.

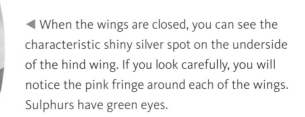

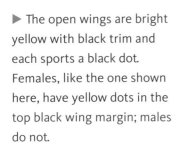

◀ When the wings are closed, you can see the characteristic shiny silver spot on the underside of the hind wing. If you look carefully, you will notice the pink fringe around each of the wings. Sulphurs have green eyes.

Clouded Sulphur

* **Clouded Sulphur caterpillars are as green as grass** and almost impossible to find on their host plant. Unless you actually witness a female Sulphur butterfly laying her eggs, you will probably never see the tiny eggs or the resulting caterpillars.

* **More of a challenge to photograph** than other species, we find the Sulphur skittish, and its flight pattern seems to go all over the place!

* **Puddles are attractive** to Sulphurs; they like the salts they find there.

* **Females may be yellow or white.** You can tell a Cabbage White butterfly from a Sulphur by the pink edges around the Sulphur's wings and the characteristic silver spot on the hind-wing's underside.

* **Sulphurs seem to like yellow flowers;** we often see them sipping nectar from dandelions. The yellow background acts as a kind of camouflage.

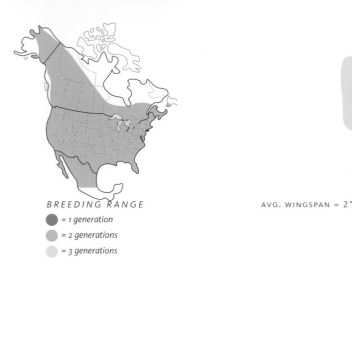

BREEDING RANGE

⬤ = 1 generation

◐ = 2 generations

○ = 3 generations

AVG. WINGSPAN = 2"

LIFE CYCLE SEASON

MAR	APR	MAY	JUN	JUL	AUG	SEP	OCT

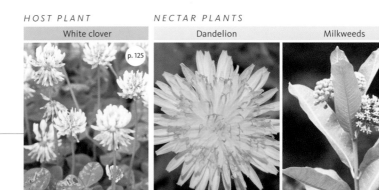

HOST PLANT

White clover — p. 125

NECTAR PLANTS

Dandelion — p. 129

Milkweeds

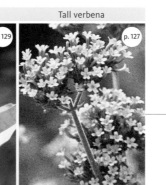

Tall verbena — p. 127

Pearl Crescent

(PHYCIODES THAROS)

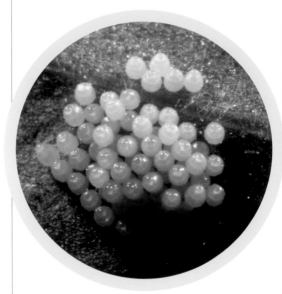

Look for clusters of very small eggs on aster leaves.

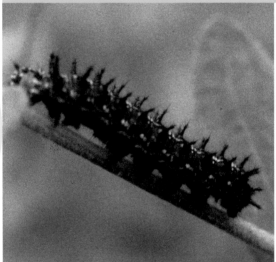

The young caterpillar eats the leaves of aster plants. As cold weather approaches, it stops eating and spends the winter resting at the base of the plant until spring arrives.

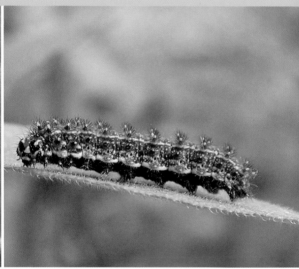

The caterpillar has brown spines, sometimes with a white tip and an orange base.

SOMETIMES KNOWN AS THE PEARLY CRESCENTSPOT, this butterfly can be seen in open meadows or wherever asters grow in profusion. They're not very big, but they're very common, flapping and coasting not far from the ground, just above the level of the flowers they love.

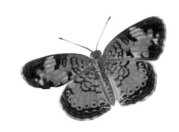

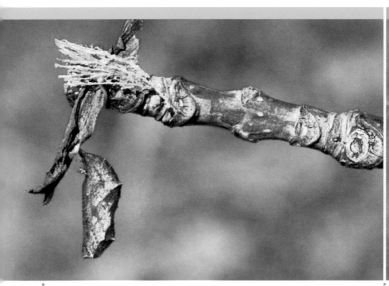

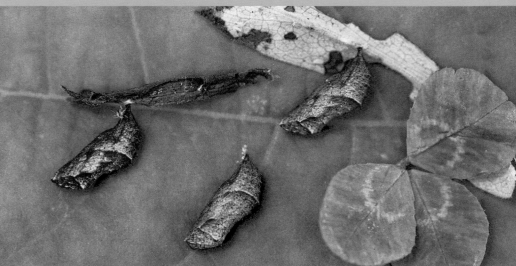

Sometimes the caterpillar stays on the original host plant to make its chrysalis. The dull brown of the chrysalis makes it look very much like a small dead leaf hanging from a stem.

Here are three Pearl Crescent chrysalises next to a clover leaf (at right). Notice how little they are!

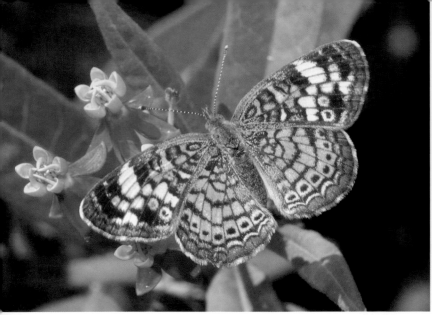

▲ The female of the species has more black coloration on her wings.

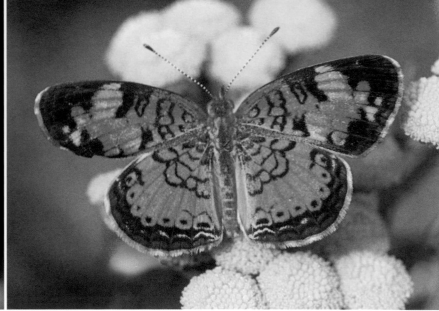

▲ The male has more orange areas on his wings.

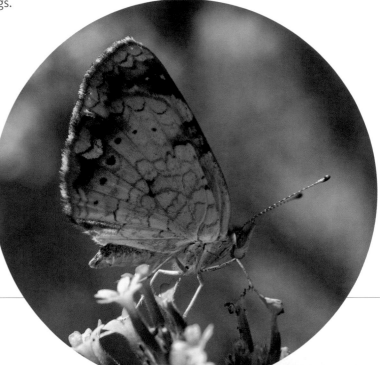

◀ The underside of the wings reveals intricate details.

Pearl Crescent

* **Pearl Crescent caterpillars eat very little** foliage from their host aster plants. Your flowers will continue to look nice, even when the caterpillars are living on them.

* **These butterflies seem just to show up overnight** in late summer as our asters are beginning to bloom. They are one of the most common butterflies we see as we walk through woods that adjoin wild meadows.

* **Fast, erratic flight** characterizes the Pearl Crescent: The butterfly darts from flower to flower, low to the ground.

* **Pearl Crescent butterflies are so small** they can stand on a blade of grass.

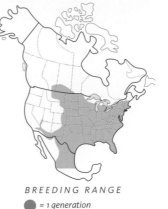

BREEDING RANGE

● = 1 generation
● = 2 generations
○ = 3 generations

AVG. WINGSPAN = 1¼"

LIFE CYCLE SEASON

| MAR | APR | MAY | JUN | JUL | AUG | SEP | OCT |

HOST PLANTS

Asters

p. 116

NECTAR PLANTS

Coneflowers

p. 127

Tall verbena

p. 127

Zinnia

p. 131

Pearl Crescent 111

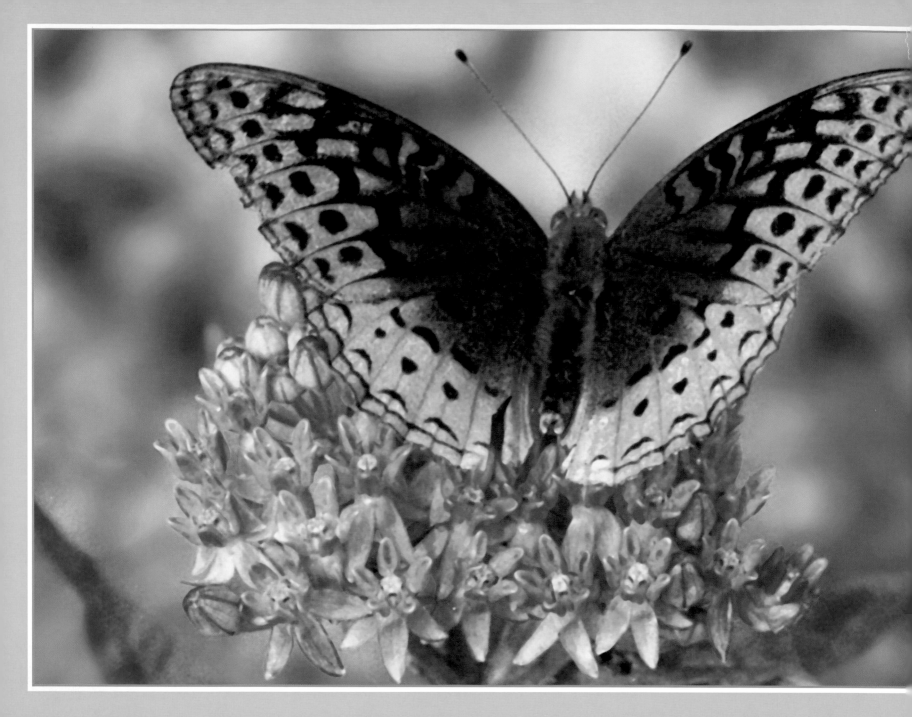

Butterfly Habitat Gardening

GARDENING FOR BUTTERFLIES can be a very rewarding experience. The best way to attract butterflies to your yard is to provide the goodies they seek. Because caterpillars and adult butterflies are vulnerable to chemicals, it is extremely important that you do not use pesticides or herbicides in their habitat. It is also a good idea to wash your hands before you handle any of the host plants in your garden. Caterpillars are sensitve to bacteria, nicotine, household cleansers, and other residues on your skin.

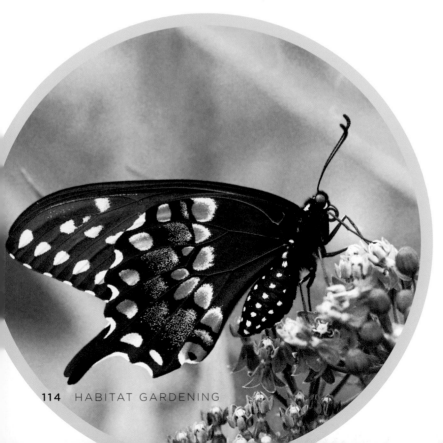

▼ Eastern Black Swallowtail on swamp milkweed.

BUTTERFLIES ARE ON A LIQUID DIET: Everything they eat must be slurped through their strawlike tongues. Most butterflies appreciate an assortment of nectar-rich flowers and blooming shrubs. For those that prefer to feed on soft, rotting fruit and tree sap, you can set out old bananas, watermelon, apples, and plums in a bowl or tray. Maple syrup is a good substitute for tree sap. Male butterflies may also appreciate a shallow pan of dirt and sand mixed with sea salt, kept moist so they can sip the dissolved minerals.

There are plastic butterfly feeders on the market that are similar to hummingbird feeders. If you decide to try your hand at one of these, use a 10 percent sugar solution instead of the standard 20 percent solution that hummingbirds drink. It is probably best to use fructose sugar; regular cane sugar may recrystallize inside the butterfly's body and cause it harm. To make the solution, bring 2¼ cups of distilled water to a boil. Remove the pan from the heat and stir in ¼ cup of sugar until it is completely dissolved. Keep the mixture in the refrigerator until you're ready to use it.

Remember to sterilize the feeder at least once a week before refilling it. We've had limited success with ours and usually attracted butterflies only when we put a piece of overripe fruit on the feeder. The best and most reliable way to attract butterflies is by providing natural sources of flower nectar. Butterflies are much more likely to feed from plants than from plastic feeders.

Host Plants

IF YOU ARE SERIOUS about gardening to attract butterflies, your primary focus should be host plants, the plants on which females lay their eggs. Each species of butterfly requires specific plants for its caterpillars to eat. As a matter of fact, a caterpillar will starve to death before it eats any plant other than its own host. On the following pages you'll learn about the host plants of the butterflies we highlight in this book. This is not an exhaustive list, and we encourage you to look at other butterfly and plant references (see References, p. 145). We hope the information we have provided helps you design your own butterfly habitat garden.

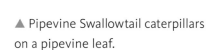

▲ Pipevine Swallowtail caterpillars on a pipevine leaf.

▶ Dark form of the female Tiger Swallowtail on a coneflower.

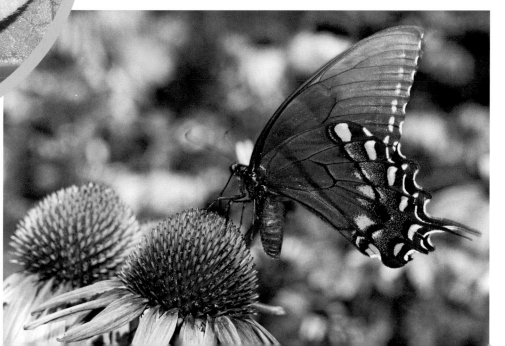

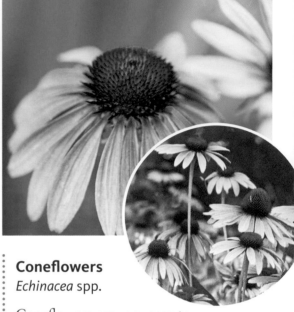

Artemisia
Artemisia stelleriana

This artemisia grows very low to the ground in our gardens — about six inches tall — and prefers full sun. It spreads slowly, blooms in the summer, and doesn't like to be overwatered. Its leaves are feltlike and deeply lobed. If you see several leaves stuck together, there is probably a caterpillar inside.

HOST TO *American Lady*

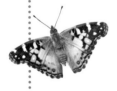

Asters
Aster spp.

There are many varieties of asters blooming in nearly every color you can imagine. The flowers are beautiful and make a wonderful splash of color in the garden. The Pearl Crescent caterpillar eats only small amounts of the foliage, so the flowers remain nicely intact. We always buy the hardy perennial species at local nurseries.

HOST TO *Pearl Crescent*

Coneflowers
Echinacea spp.

Coneflowers are very easy to grow in a sunny perennial garden. They don't mind poor soil, they tolerate occasional drought, and they bloom faithfully until the first frost, providing an abundance of nectar for every kind of butterfly and bee imaginable. The Silvery Checkerspot's small caterpillars munch only the leaves of this host plant, not the pretty flowers.

HOST TO *Silvery Checkerspot*

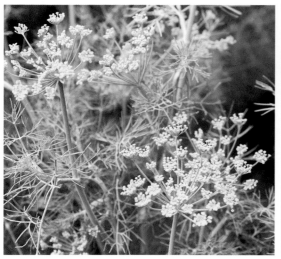
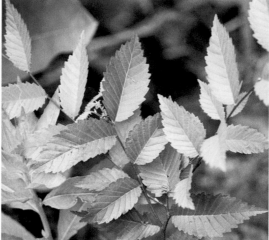

Dill
Antheum graveolens

It's easy to find dill in seed packets or as small plants in nurseries. It can grow to four feet tall, so plant it next to a fence or other support in a sunny location. A native of Europe, dill was used as a medicinal herb by the ancient Greeks and Romans. Its feathery foliage allows it to grow among other garden flowers without blocking the sunlight.

HOST TO *Eastern Black Swallowtail*

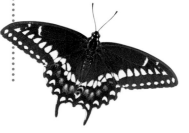

Elm trees
Ulmus spp.

We didn't plant our little elm trees ourselves: They were probably a "gift" from the birds we feed. Elms don't seem to be picky about the type of soil they grow in. The butterflies that use them as hosts favor the tender new leaves for egg laying. Since elm trees can grow quite large, we suggest keeping them pruned to a manageable size.

HOST TO *Eastern Comma, Question Mark*

False nettle
Boehmeria cylindrica

Although this plant belongs to the nettle family (*Urticaceae*), it lacks the irritating hairs of stinging nettle. It's perennial and native to the southern United States. False nettle grows wild in shady woodlands and reaches a height of two to three feet. It blooms in summer, bearing spikes of small greenish flowers. We grow ours in full sun, but it must be watered regularly. Cut off the top of the plant to make it branch out and grow more leaves for hungry caterpillars.

HOST TO *Eastern Comma, Question Mark, Red Admiral*

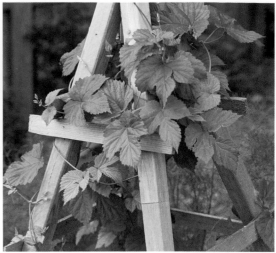

Fennel
Foeniculum vulgare

You can buy fennel in seed packets or as small plants in nurseries. Fennel can grow as tall as six feet, so it's best to find a sunny place for it in the back of the garden. All parts of this native Mediterranean plant are edible. It can cross-pollinate with dill, causing a loss of flavor in the resulting seeds. Chew on a fennel leaf if you like the taste of black licorice.

HOST TO *Eastern Black Swallowtail*

Hollyhocks
Alcea spp.

Among the easiest of the Painted Lady host plants to find in our local nurseries, hollyhocks make a pretty garden flower and provide large leaves for caterpillars to eat. Since the caterpillars eat only the foliage, try cutting off the blooms to encourage more leaf growth; this will help attract egg-laying females.

If allowed to bloom, hollyhocks grow to about five feet tall and need some support to stay upright. They need full sun and well-drained soil. Their leaves tend to turn yellow if the plants are overwatered.

HOST TO *Painted Lady*

Hop vines
Humulus spp.

We ordered our hop vines as bare roots from a nursery on the Internet because we couldn't find them locally. They need to be grown in full sun, where they'll quickly cover a trellis with leaves that feel like sandpaper on your skin. In their first year they grow slowly, but after that they spread like crazy via underground runners. They perform best in well-drained soil.

HOST TO *Eastern Comma, Question Mark*

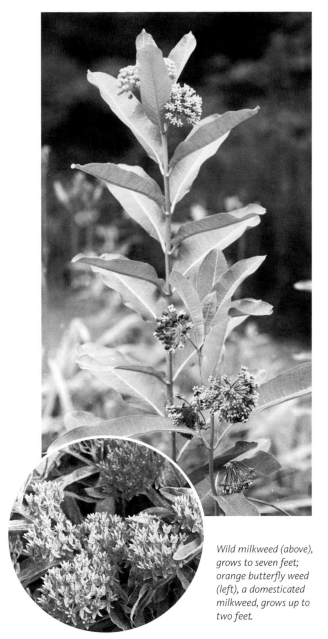

Milkweeds
Asclepias spp.

Milkweeds come in a variety of heights, shapes, and colors. Many grow wild in fields, in gravel parking lots, and along roadsides. Each species contains a different level of toxic glycosides, which are eaten and absorbed into the body of the caterpillars, making them difficult for some predators to digest. The wild milkweeds, which spread by underground runners and can grow to seven feet tall, do not transplant well and should be collected only as fall seedpods.

Check your local nurseries for more-domesticated plants such as pink swamp milkweed, 'Ice Ballet' milkweed, bloodflower, and orange butterfly weed. Most are perennials. Grow them in well-drained soil in full sun; their summer blooms will attract all nectar-loving insects.

HOST TO *Monarch, Queen*

Wild milkweed (above), grows to seven feet; orange butterfly weed (left), a domesticated milkweed, grows up to two feet.

Passion vines
Passiflora spp.

Some passion vines are winter-hardy, whereas others are more tropical and won't survive freezing temperatures. The ones we grow have lovely lavender flowers in summer and spread more each year by sending out underground runners. They will quickly cover a fence, arbor, or large trellis and require very limited care. These vines can grow 20 feet or more in one season, so be sure to allow plenty of room for them in your garden.

HOST TO *Gulf Fritillary, Variegated Fritillary, Zebra Longwing*

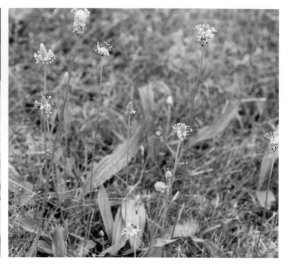

Pawpaw tree
Asimina triloba

Pawpaw trees are normally found in damp wooded areas. We grow ours in full sun and prune them hard each fall to encourage a nice compact growth habit.

If you want a pawpaw to produce fruit, you'll need to plant at least two for cross-pollination. The fruit usually ripens in September and tastes something like a banana. The tree prefers moist soil and stays insect-free except for the occasional Japanese beetle.

HOST TO *Zebra Swallowtail*

Pipevine
Aristolochia macrophylla

The pipevine is a fast-growing plant that will tolerate full sun or partial shade. It has large heart-shaped leaves and sends runners underground to spread new vines. New leaves sprout in the spring from last year's woody stems. The vines bloom in the spring and summer with funny little pipelike flowers.

There are several species of pipevine; some are winter-hardy, while others are tropical. We plant only Dutchman's pipe (*A. macrophylla*) in our gardens because it offers the largest and most plentiful leaves for caterpillars.

HOST TO *Pipevine Swallowtail*

Plantain
Plantago lanceolata

Plantain is a common weed that grows wild just about everywhere. It will grow flat against the ground if constantly mowed, but if left alone, it can reach 12 inches tall! We just transplanted ours from the front lawn to the backyard garden. It's happiest in full sun. In summer it develops tall, slender stalks topped by small brown flower heads with tiny white blooms at the tip.

HOST TO *Common Buckeye*

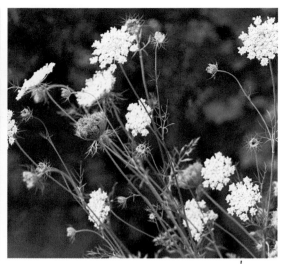

Plantain-leaved pussytoes
Antennaria plantaginifolia

This host plant is low growing, its smooth-edged oval leaves almost touching the ground. It prefers shady areas and spreads slowly; its springtime blooms look like tiny white kitten paws. Caterpillars often hide by sticking together several of the pussytoes' fuzzy silvery white leaves.

HOST TO *American Lady*

Prickly ash
Zanthoxylum americanum

Prickly ash does best in full sun and moist soil. It grows wild in damp woodland areas, but if you plant it in a sunny spot and prune it every fall, it will form an attractive shrub. You can easily dig up and transplant the volunteers that sprout from its underground runners. Prickly ash does have thorns (hence the name), so be extra careful when handling it.

HOST TO *Giant Swallowtail*

Queen Anne's lace
Daucus carota

Queen Anne's lace grows wild just about everywhere, and you can easily collect the seed heads in the fall. The wild plants don't transplant well because of their deep taproot, which can be washed and eaten just like a carrot (the plant is also known as wild carrot). Queen Anne's lace can grow as tall as six feet, so make sure it's in the back of a sunny part of your garden. Caterpillars will eat both the leaves and the flowers.

HOST TO *Eastern Black Swallowtail*

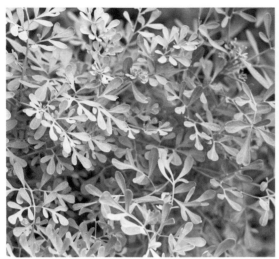

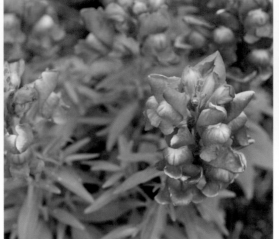

Rue
Ruta graveolens

Although it can be difficult to find in our local nurseries, rue's unusual bluish green foliage makes it an attractive addition to our herb gardens. Rue prefers full sun and soil that is well drained, even bone-dry. It will grow to a height of about two feet. If you cut back the old blooms, the plant will put out new growth during the summer.

HOST TO *Giant Swallowtail*

Snapdragon
Antirrhinum majus

Widely available at local nurseries, snapdragons come in many flower colors. The plants prefer full sun, and they'll bloom all summer long if they're watered regularly. Remove the old blooms to encourage new flowers. Butterflies seem to prefer to lay their eggs on the lower-growing varieties rather than on those that grow tall and lanky.

HOST TO *Common Buckeye*

Spicebush
Lindera benzoin

Spicebush is an eastern North American native woodland shrub that can tolerate a wide variety of growing conditions. It'll grow in sun or shade and doesn't seem to mind poor soil. It can easily be pruned to become a denser plant that provides hundreds of leaves for the caterpillars to gnaw on. Cutting the stems releases a pungent, spicy smell.

HOST TO *Spicebush Swallowtail*

Spider flower
Cleome spinosa

Heat- and drought-tolerant, spider flower blooms from early summer until the first frost. It's an annual, but in the fall it drops seeds that will sprout the following spring. Flower colors range from pure white to shades of pink and purple. Attractive to hummingbirds as well as butterflies, plants can reach heights of five feet or more, but you can cut the top to force a shorter, denser growth habit, and to keep the plants from leaning over after a hard rain.

HOST TO *Cabbage White*

Sweet bay magnolia
Magnolia virginiana

A relatively small tree with a rather sparse leaf count, sweet bay magnolia will grow in shade, although it thrives and blooms better in full sun. It's a slow-growing, shrubby tree that needs very little pruning. Its white flowers smell heavenly when they bloom in early summer.

HOST TO *Tiger Swallowtail*

The dark form of Tiger Swallowtail.

Tulip poplar.

Tulip poplar
Liriodendron tulipifera

The tulip poplar can grow several stories tall and requires plenty of room in your yard to stretch out and up. Tiger Swallowtails that use it as a host lay their eggs one to a leaf on the uppermost parts of the tree. We keep our tulip trees pruned short so that we can more easily find the eggs and caterpillars. The tree is winter-hardy and readily available in nurseries. It's sensitive to drought conditions, though, so water it regularly to keep it healthy in the heat of summer.

HOST TO *Tiger Swallowtail*

Violets
Viola spp.

Often found growing in lawn grass, violets can be easily transplanted to safer ground. They're also fairly easy to find at nurseries. They usually prefer shady, moist areas but will tolerate full sun. Butterflies use the wild, perennial viola species as host plants, laying their eggs on the leaves in summer.

HOST TO *Variegated Fritillary*

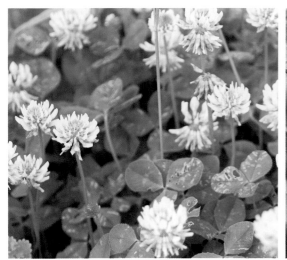

White clover
Trifolium repens

White clover is probably already growing in your lawn. We grow a special patch just for the butterflies — protected from the lawn mower, of course! You can either transplant a clump of clover or buy the seeds and sow them wherever you like.

HOST TO *Clouded Sulphur*

Willows
Salix spp.

Willows are winter-hardy trees and shrubs that are available in many varieties and leaf shapes. We've found them to be very easy to grow, especially in wet areas of our yards. They grow so fast that we prune them often and easily root the cuttings in a vase of water. Be careful to check for butterfly eggs and caterpillars before you prune, however! And don't prune in the fall: The caterpillars need the leaves as a place to overwinter.

HOST TO *Red-spotted Purple, Viceroy*

(top) Corkscrew willow (Salix matsudana)
(bottom) Pussy willow (Salix discolor)
(right) Dwarf blue leaf arctic willow (Salix purpurea)

Our Top Nectar Flowers

JUST AS SOME PEOPLE ENJOY EATING at a good buffet restaurant, butterflies like to drink nectar from a variety of flowers. The more flowers you grow in your garden, the more likely you are to see hungry butterflies sampling the menu.

Butterflies tend to prefer plants that have clusters of flowers: They don't have to travel very far between sips! Each tiny bloom offers a droplet of sugary nectar (along with traces of vitamins and minerals) that the insect can easily convert into energy.

Even though there are many gorgeous flowers to choose from, the following plants are the ones that have given us the best results. The perennial plants have proved to be hardy in our Zone 6 Kentucky gardens and, along with the annuals, attract large numbers of beautiful butterflies to their colorful flowers.

This monarch is enjoying nectar from the blooms of a pink butterfly bush.

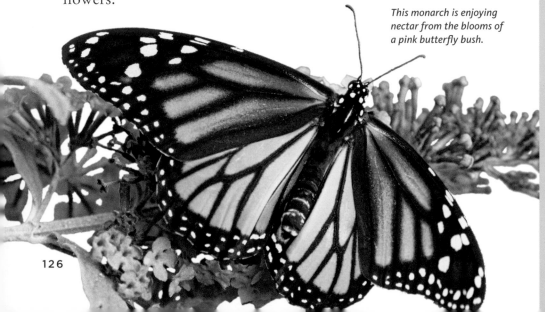

126

1. **Tall verbena**
 Verbena bonariensis

2. **Coneflowers**
 Echinacea spp.

3. **Lantana**
 Lantana camara

4. **Butterfly bush**
 Buddleia davidii

5. **Milkweeds**
 Asclepias spp.

6. **Mexican sunflower**
 Tithonia rotundifolia

7. **Tall garden phlox**
 Phlox paniculata

8. **Sunflowers**
 Helianthus spp.

9. **Zinnia**
 Zinnia elegans

10. **Cosmos**
 Cosmos bipinnatus

11. **Sweet William**
 Dianthus barbatus

12. **Egyptian starflower**
 Pentas lanceolata

13. **Petunia**
 Petunia x hybrida

TALL VERBENA

This tall species of verbena (*Verbena bonariensis*) is a native of Brazil. Its airy stems and narrow leaves allow it to grow in among other flowers and plants in the garden without overcrowding them. It prefers full sun and tolerates wet or dry soil. We have seen nearly every kind of local butterfly drawn like a magnet to the lavender flowers, which appear continuously until winter. The plant drops hundreds of seeds in the fall and may return from the roots, although you can't count on it. Be sure to sow verbena seeds after the danger of frost is past.

CONEFLOWERS

Coneflowers (*Echinacea* spp.) are winter-hardy perennial plants that thrive in full sun and tolerate poor soil, even the Kentucky clay in our yards. They don't seem to mind an occasional drought, either. They're absolutely irresistible to a multitude of butterfly species and will bloom nonstop from late spring until the first frost. As an added bonus, the seeds on the spent flower heads are a favorite food for goldfinches. They eagerly pull apart the old flowers to get to the seeds inside. To increase blooms, cut off any faded flowers down to the next leaf joint. Throw them on the ground to feed the birds if you'd like, or scatter the seeds in your flower bed. Coneflowers are a must-have for any butterfly habitat garden.

LANTANA

An annual in our Kentucky gardens, lantana (*Lantana camara*) makes an excellent container plant, and it comes in several shades of yellow, orange, red, and pink. The dark berries that form after the flowers fall off are toxic if eaten by kids or pets. Keep the spent flowers cut off to avoid this problem and to encourage blooms all summer long, until the first frost of autumn.

Lantana requires full sun and must be watered frequently if you grow it in a pot. The larger butterflies are attracted to the flowers, most likely because they have tongues long enough to reach into the tubes and extract the sweet nectar inside.

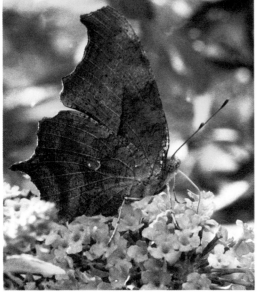

BUTTERFLY BUSH

This shrub requires full sun in order to bloom to its full potential. Remove the faded flowers to encourage continual blooming until the first frost. In our gardens, butterfly bush (*Buddleia davidii*) dies back during the winter months. To ensure the best flowers the following year, we prune down the entire bush to about a foot tall in winter or early spring. Otherwise, the shrub may become lanky and produce smaller blooms. Without good drainage, butterfly bush is prone to root rot, so keep this in mind when you decide on a location.

This Question Mark would normally be attracted to tree sap and rotting fruit, but couldn't resist the blossoms of a butterfly bush.

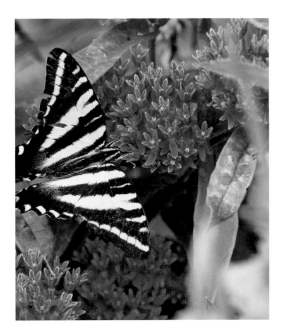

This variety is called orange butterfly weed or orange glory flower. It's a shorter plant than the other milkweeds but is very rich in nectar.

MILKWEEDS

These perennials come in several flower colors, and all serve as excellent nectar sources. Milkweeds (*Asclepias* spp.) bloom best when grown in full sun and well-drained soil. To encourage more blooms, cut off the spent flowers at a leaf joint.

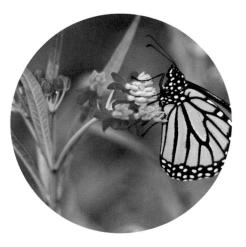

This species of milkweed is called Bloodflower. It is not winter-hardy so we grow it as an annual.

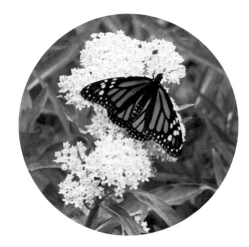

'Ice ballet,' the milkweed variety shown here, prefers a sunny location.

This Common Buckeye butterfly feeds from a pink swamp milkweed.

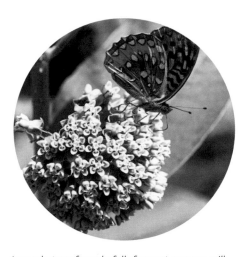

Large clusters of wonderfully fragrant common milkweed blooms attract Great Spangled Fritillary butterflies (page 136) and many other species, including Monarchs.

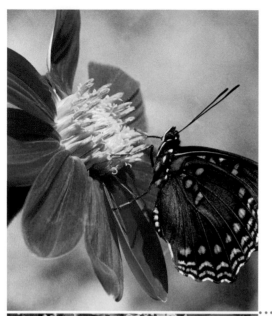

MEXICAN SUNFLOWER

Mexican sunflower (*Tithonia rotundifolia*), which can grow to seven feet tall, requires a fairly large space in the garden to spread out its lanky limbs. This plant excels at producing an incredible amount of sweet nectar that will quickly draw butterflies, bees, and hummingbirds into your flower garden. A summer-blooming annual that lasts until the first frost, Mexican sunflower needs full sun and grows just fine in poor soil.

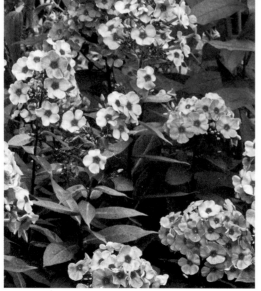

TALL GARDEN PHLOX

Tall garden phlox (*Phlox paniculata*) is an old-fashioned garden perennial. It comes in many flower colors, including white and shades of pink, lavender, and purple. Plant it in full sun in well-drained soil. Growing about three feet tall and needing very little care, it blooms during the summer months. Removing the old flowers, or cutting them for bouquets, will encourage more blooms. Only the larger butterflies, with their longer tongues, sip nectar from phlox.

SUNFLOWERS

The many kinds of sunflower (*Helianthus* spp.) come in a vast array of flower sizes, colors, and petal counts. The Russian giant variety is exactly that: huge! It can reach a height of over 12 feet, while dwarf species are as small as just a foot high. It's pretty obvious that sunflowers require full sun. They provide nectar and pollen for butterflies and bees, and the ripe seeds of this annual feed birds and squirrels.

ZINNIA

Zinnia (*Zinnia elegans*) is an easy annual flower to grow in a nice sunny spot in your garden. Plant varieties with flat-faced flowers to attract the most butterflies. They offer a better landing pad and nectar that is more easily accessible than do varieties packed full of petals. Many types of zinnia are readily available in local nurseries and come in a rainbow of vivid colors.

COSMOS

Cosmos (*Cosmos bipinnatus*) is a very carefree annual that comes in many flower colors, including white, pink, orange, and yellow. Plant it in full sun toward the back of the garden: It can get quite tall, and it tends to lean over in a hard rain. Buy cosmos in seed packets or as young plants in the spring. All sizes of butterflies can reach the nectar in these flowers. Dwarf cosmos varieties are also available: They grow to about two feet tall rather than the usual five feet.

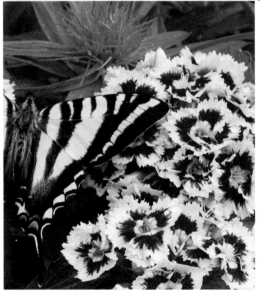

SWEET WILLIAM

Sweet William (*Dianthus barbatus*) is a hardy biennial flower that needs full sun and well-drained soil. It is among the first to bloom in early spring when almost everything else is still dormant. Cut it back for a second flush of blossoms. Flowers come in white, red, pink, burgundy, and a mixture of bicolors.

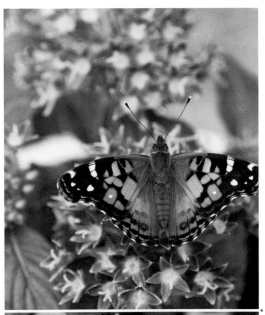

EGYPTIAN STARFLOWER

This lovely annual (*Pentas lanceolata*), which comes with white, pink, or red blossoms, makes a great container plant. It prefers sun but will grow in partial shade, but does not like soggy soil. As you do with most other annuals, cut off the old flowers to promote new blooms throughout the summer months. Egyptian starflower requires very little care.

PETUNIA

Great in hanging baskets or along the front border of your garden, this petunia (*Petunia* x *hybrida*) is a showy annual that comes in a rainbow of solid flower colors and pinwheel stripes. Grow it in full sun, keep it well watered, and watch the hummingbirds go crazy for it. The swallowtails seem to be the only butterflies with tongues long enough to reach the nectar.

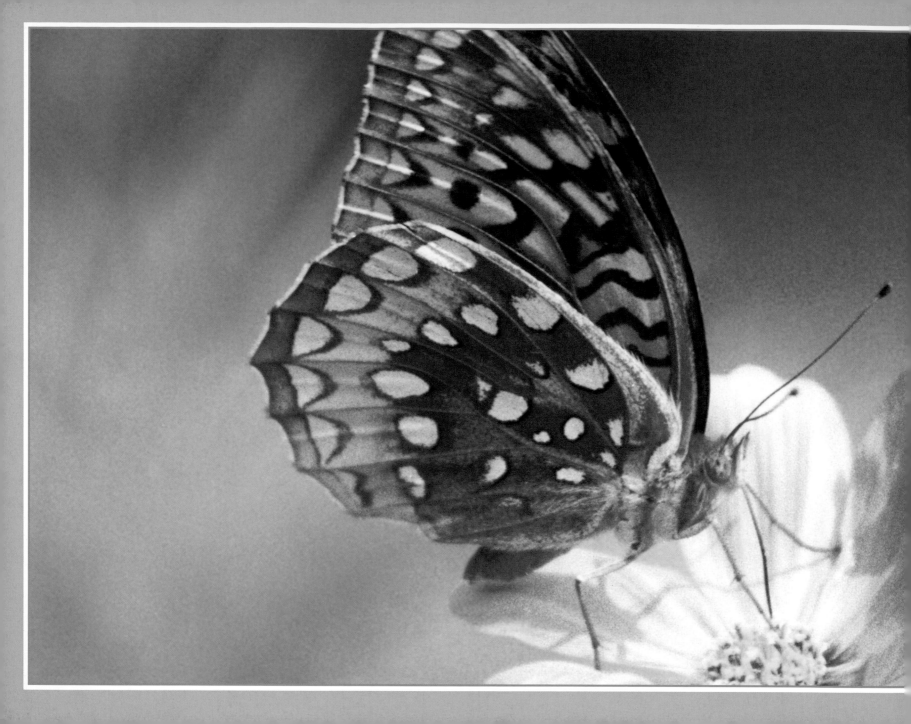

Other Garden Visitors

ALTHOUGH WE'RE PROUD TO HAVE CAPTURED, on film, the full life cycle of 23 butterflies, there have been many other winged visitors passing through our gardens that we haven't been able to document in as much detail, and some that we've seen only a single time. On the next few pages you'll see our photos of some of these butterflies, and read what we've managed to learn about them during our many years of study. They are arranged in order of the frequency that we've seen them in our gardens, from most to least frequent. See any familiar faces? Maybe our occasional butterflies are "regulars" in your garden!

Assorted Butterflies

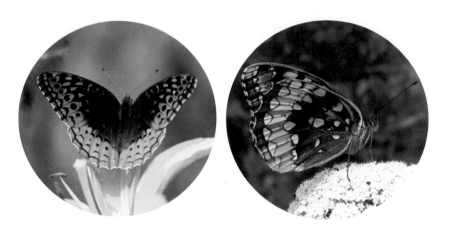

Great Spangled Fritillary
(SPEYERIA CYBELE)

The Great Spangled Fritillary reproduces only once, laying its eggs near the base of violets (*Viola* spp.) in the summer. The caterpillars hatch, eat their eggshells, and then hibernate all winter. They wake up in the spring to eat young violet leaves at night and hide on the ground under the plant during the day. Easily approached while it is busy sipping nectar, the adult butterfly is especially fond of our milkweeds and coneflowers. This largest of the fritillary butterflies has metallic silver spots on the underside of its wings.

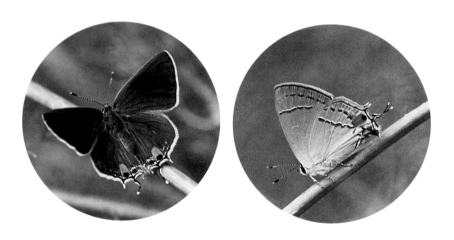

Gray Hairstreak
(STRYMON MELINUS)

Gray Hairstreak females lay their tiny green eggs on the flowers of clover, bean, hibiscus, cotton, and many other host plants. The caterpillar bores into fruits and seeds, and it spends the winter as a chrysalis. The skinny tails of the butterfly look and move like an extra pair of antennae, which may fool predators into biting the wrong end, thus saving the butterfly's head. The Hairstreak almost always perches with its wings closed to eat, so it is very difficult to photograph with its wings open. But we got lucky! These photographs show the details of this beautiful butterfly, which is about the size of a nickel.

Little Wood-Satyr
(MEGISTO CYMELA)

The Wood-Satyr is most commonly found at the edges of shady woodlands and meadows. It flies low among the grasses and shrubs and dances around from plant to plant, seldom resting in one spot for very long. It lays its green eggs singly on various grasses. The Little Wood-Satyr caterpillar is brown with white stripes. It can be found in both open fields and deep woods. The adult butterfly is not interested in flowers but feeds instead on tree sap, animal dung, and rotting fruit.

Hackberry Emperor
(ASTEROCAMPA CELTIS)

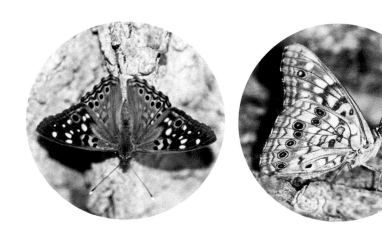

The Hackberry Emperor loves to eat oozing, sticky tree sap. It may not visit your flower garden unless you bribe it with some very rotten fruit, one of its favorite foods. It is also attracted to animal dung and the salt on the skin of a sweaty gardener. The caterpillar eats the leaves of hackberry trees (*Celtis* spp.). The Hackberry Emperor can be distinguished from its close cousin the Tawny Emperor (page 138) by the white dots and eyespot on the top of its upper wings. The Tawny Emperor lacks these features.

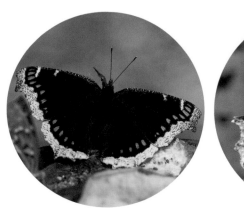

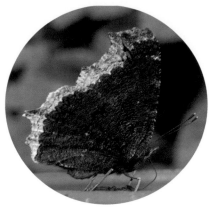

Mourning Cloak
(NYMPHALIS ANTIOPA)

Unlike other short-lived butterflies, the Mourning Cloak is able to survive for almost a year. The females lay their eggs in clusters on the branches of willows or other trees and shrubs. When they hatch out, the caterpillars eat together as a group on the leaves. The adult butterflies feed on rotting fruit, tree sap, nectar from fruit tree blossoms, and animal droppings. They rest during the hot summer months in a state of *aestivation*, then start feeding again in the fall. They spend the winter as unmated adult butterflies, hiding under loose tree bark or in woodpiles until spring, when they mate.

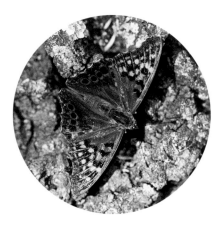

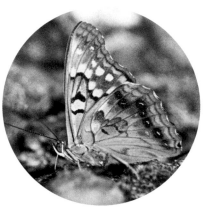

Tawny Emperor
(ASTEROCAMPA CLYTON)

The female Tawny Emperor lays her eggs in clusters on hackberry trees (*Celtis* spp.). She can lay hundreds of eggs during her short life span. Often this butterfly can be seen with the Hackberry Emperor (page 137), sipping leaking tree sap; it also dines on carrion, dung, rotting fruit, and, rarely, on flower nectar. The caterpillars lie flat in a silk mat on the underside of a leaf when they're not eating. They spend the winter hiding in a group among dead, curled leaves.

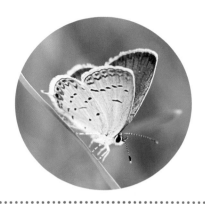

Eastern Tailed-Blue
(EVERES COMYNTAS)

The female lays her eggs in the flowers of plants in the Pea family, such as alfalfa, clover, and bean, and the caterpillars hibernate inside the seedpods during the winter months. What a beautiful touch of blue this butterfly adds to your garden.

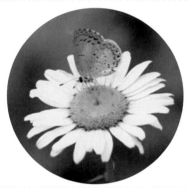

Summer Azure
(CELASTRINA LADON NEGLECTA)

This is the summer form of the Spring Azure butterfly. The caterpillars eat the flowers of dogwood trees, viburnum shrubs, and blueberry plants. To bribe ants into protecting them from other insects, the caterpillars secrete honeydew from a special gland.

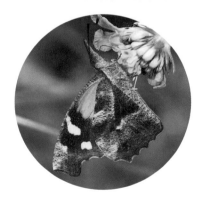

American Snout
(LIBYTHEANA CARINENTA)

The American Snout butterfly gets its name from its very long *palps* (furry parts of its face), which look like a big nose of sorts. This woodland butterfly lays its eggs on the young leaves of hackberry trees. From the eggs hatch green caterpillars with white stripes along both sides of their bodies. The adult butterfly has a rapid, erratic flight pattern and will sip nectar from flowers and juices from old fruit.

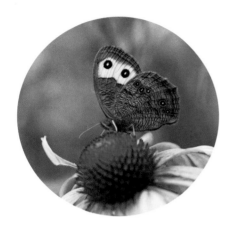

Common Wood-Nymph
(CERCYONIS PEGALA)

This little butterfly visits our gardens occasionally. It usually stays at the edges of woodlands and in overgrown fields. The caterpillars eat grasses instead of plant leaves, and the adults sip flower nectar and the juices of rotting fruit. The common Wood-Nymph darts around with quick spurts of flight from plant to plant. We have to be extra stealthy to sneak up on this wary butterfly.

Northern Pearly-Eye
(ENODIA ANTHEDON)

The Northern Pearly-Eye butterfly is usually found in woods and meadows near a water source. Various grasses serve as host plants for its eggs. It flies close to the ground and often lands on dirt trails and tree trunks. Northern Pearly-Eye caterpillars can be either pale green or light brown, with tiny red-tipped horns on their head. Look for them in wooded areas near streams.

Assorted Skippers

SKIPPERS TEND TO ACT like butterflies but often look more like moths. There are more than 200 species of skippers in North America, and it can be very tricky to identify them correctly, so here are some examples of those most likely to appear in your backyard butterfly habitat.

You'll recognize a skipper by its short, thick body and small antennae, each ending in a little hook. On other butterflies the tip of each antenna is rounded. Skippers have a very quick, erratic flight pattern.

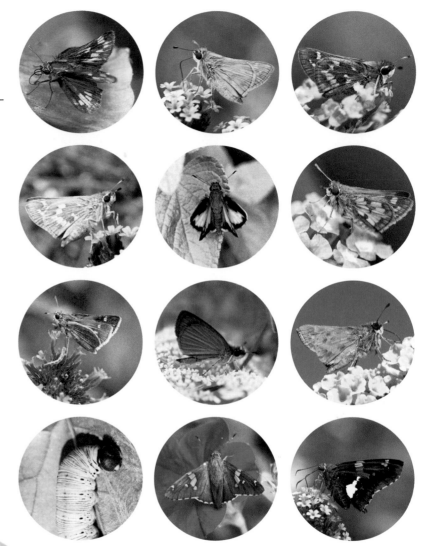

▲ Here's a small sampling of the wide variety of skippers found in North America.

MOTH OR BUTTERFLY?

If you look at all the world's species of lepidoptera (moths and butterflies) as a group, you'll find that almost 90 percent are moths. Butterflies only seem to be more abundant because they fly during the day, when we can see them.

Here are some ways to tell the difference between a moth and a butterfly.

* As a general rule, moths fly at night and butterflies are active during the daylight hours.

* Moths tend to have thick, fuzzy, heavy bodies.

* Moths, especially males, have antennae that look like feathers.

* Caterpillars of the large moths often eat for many weeks or even for months, unlike butterfly caterpillars, which eat for 10 to 15 days.

* Some moth caterpillars have irritating or stinging hairs and must be handled with great care.

* Moth chrysalises are wrapped in a cocoon of silk threads.

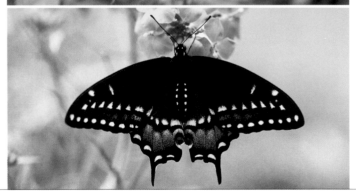

▶ (FROM TOP) Female Polyphemus moth; male Cecropia moth; female Eastern Black Swallowtail butterfly.

Glossary

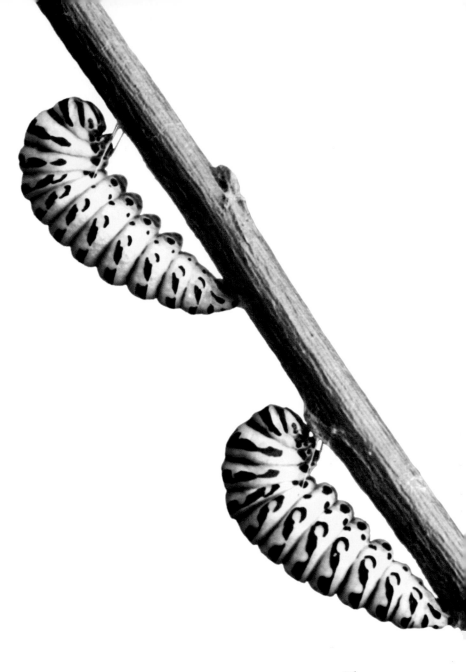

Abdomen The rear part of an insect's body containing the digestive and reproductive organs

Aestivation Dormancy during a hot, dry season

Annual Any plant that lives for just one season and doesn't come back next year from the roots

Antennae A pair of sensory organs on the head used to touch and smell an insect's environment

Basking Spreading wings open and sitting still in the sunlight to absorb heat

Branched spines Pointed spikes that cover the body of some caterpillars

Chorion Protective membrane covering an egg

Chrysalis Pupa of a butterfly or moth enclosed in a firm case or cocoon

Cocoon A case, spun from silk threads, that envelops the chrysalises of moths and a few butterflies, especially skippers

Compound eyes Large insect eyes composed of hundreds of tiny lenses

Diapause The winter resting phase of some chrysalises and a few caterpillars; also called hibernation

Eclosion The emergence from a chrysalis or cocoon as an adult butterfly or moth

Embryo The developing caterpillar within an egg

Exoskeleton The shell that forms the outside of an insect's body; insects don't have bones

Girdle A loop of silk that supports a chrysalis in an upright position; Swallowtail caterpillars spin these loops

Hemolymph The blood of an insect

Host plant A specific plant on which female moths and butterflies lay their eggs; after they hatch, the caterpillars feed on the host plant

Instar The caterpillar growth period between each molt of the old skin

Invertebrate A creature that does not have a backbone; this category includes all insects

Juvenile hormone A chemical that prevents a caterpillar from turning into a chrysalis before it is mature. Once production of this hormone stops, the caterpillar enters the chrysalis phase

Larva The caterpillar phase of a butterfly or moth

Life cycle The four stages of butterfly and moth development: egg, caterpillar, chrysalis, and winged adult

Meconium Fluid left over from metamorphosis, excreted by a newly emerged adult butterfly or moth

Metamorphosis The transformation of a butterfly or moth from egg to caterpillar to chrysalis to adult

Molting The shedding of an old skin to reveal a looser, new skin underneath to grow into

Nectar The sugary liquid produced by flowers that attracts bees, butterflies, hummingbirds, and moths

Osmeterium A gland hidden behind a Swallowtail caterpillar's head that releases a foul odor for defense

Ovum A butterfly or moth egg

Palps A pair of furry appendages on the face of a butterfly or moth that protect the proboscis when it is curled up

Perennial A nonwoody plant living more than two years

Pheromones Chemical substances secreted by butterflies and other creatures to attract mates

Proboscis The tongue of a butterfly or moth that sips nectar and coils up when not in use

Prolegs Fleshy, sticky legs of a caterpillar, used for clinging to surfaces

Pupa The chrysalis phase of a butterfly or moth

Scales Tiny, overlapping structures that cover the surface of butterfly or moth wings and absorb heat

Simple eyes The microscopic eyes on caterpillars that detect only movement and light

Spinneret The gland located below the mouth of a caterpillar that spins silk threads

Spiracles Pores on the sides of an insect's body used to breathe in air; insects have no lungs

Thorax Front part of an insect's body containing the muscles connected to the wings and legs

Tubercles Lumpy projections covering the body of some caterpillars; the Cecropia moth caterpillar also has them

Vertebrate An animal that has a backbone

References

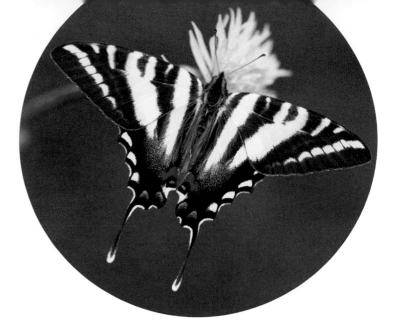

Brock, Jim P., and Kenn Kaufman, *Butterflies of North America*: Kaufman Focus Guides. New York: Houghton Mifflin Company, 2003.

Cohen, Stephanie and Nancy J. Ondra, *The Perennial Gardener's Design Primer.* North Adams, MA: Storey Publishing, 2005.

Glassberg, Jeffrey, *Butterflies through Binoculars: A Field Guide to the Butterflies of Eastern North America.* New York: Oxford University Press, 1999.

Hill, Lewis and Nancy, *The Flower Gardener's Bible.* North Adams, MA: Storey Publishing, 2003.

Mikula, Rick, *The Family Butterfly Book: Projects, Activities, and a Field Guide to 40 Favorite North American Species.* North Adams, MA: Storey Publishing, 2000.

Xerces Society/Smithsonian Institution, *Butterfly Gardening: Creating Summer Magic in Your Garden.* Sierra Club Books, 1998.

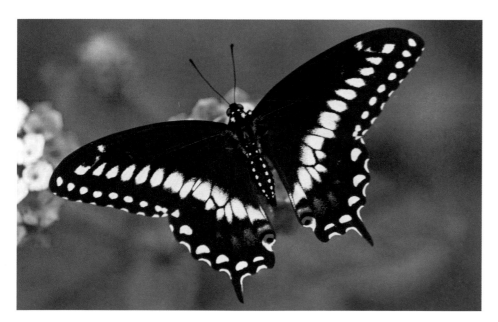

Easy Comparison Guide: Eggs

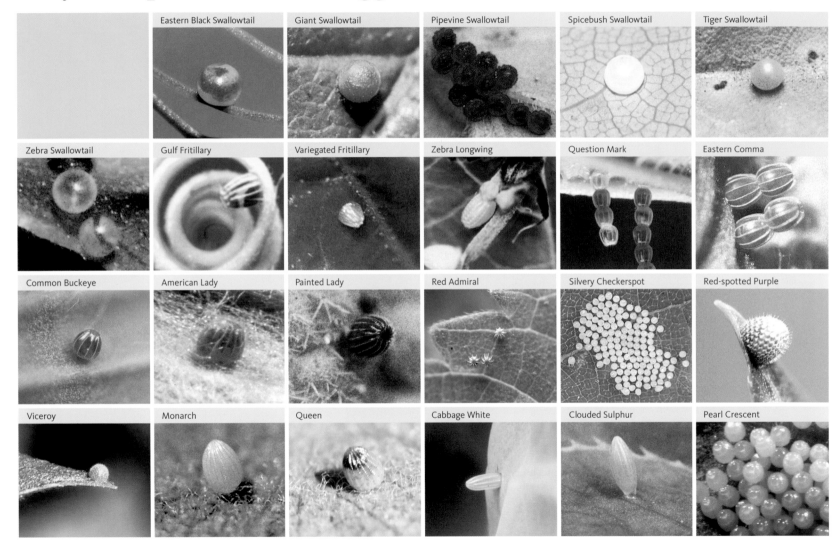

	Eastern Black Swallowtail	Giant Swallowtail	Pipevine Swallowtail	Spicebush Swallowtail	Tiger Swallowtail
Zebra Swallowtail	Gulf Fritillary	Variegated Fritillary	Zebra Longwing	Question Mark	Eastern Comma
Common Buckeye	American Lady	Painted Lady	Red Admiral	Silvery Checkerspot	Red-spotted Purple
Viceroy	Monarch	Queen	Cabbage White	Clouded Sulphur	Pearl Crescent

Easy Comparison Guide: Caterpillars

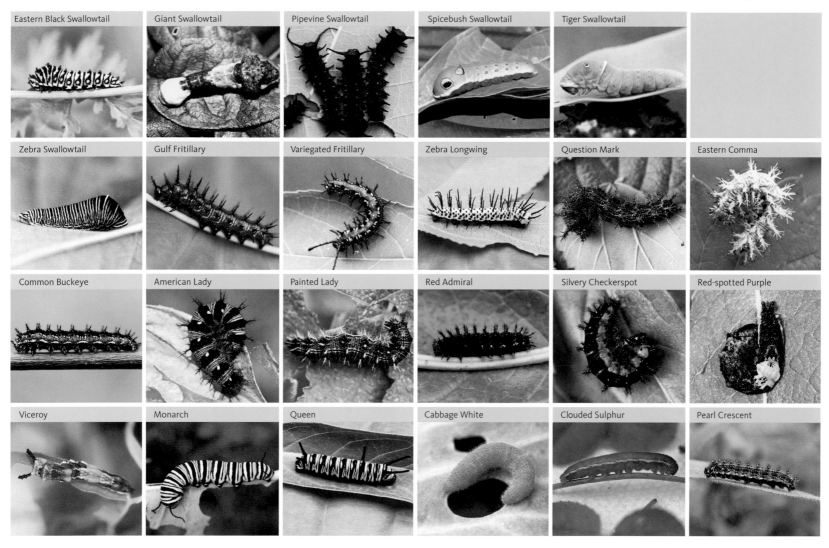

Eastern Black Swallowtail · Giant Swallowtail · Pipevine Swallowtail · Spicebush Swallowtail · Tiger Swallowtail

Zebra Swallowtail · Gulf Fritillary · Variegated Fritillary · Zebra Longwing · Question Mark · Eastern Comma

Common Buckeye · American Lady · Painted Lady · Red Admiral · Silvery Checkerspot · Red-spotted Purple

Viceroy · Monarch · Queen · Cabbage White · Clouded Sulphur · Pearl Crescent

Easy Comparison Guide: Chrysalises

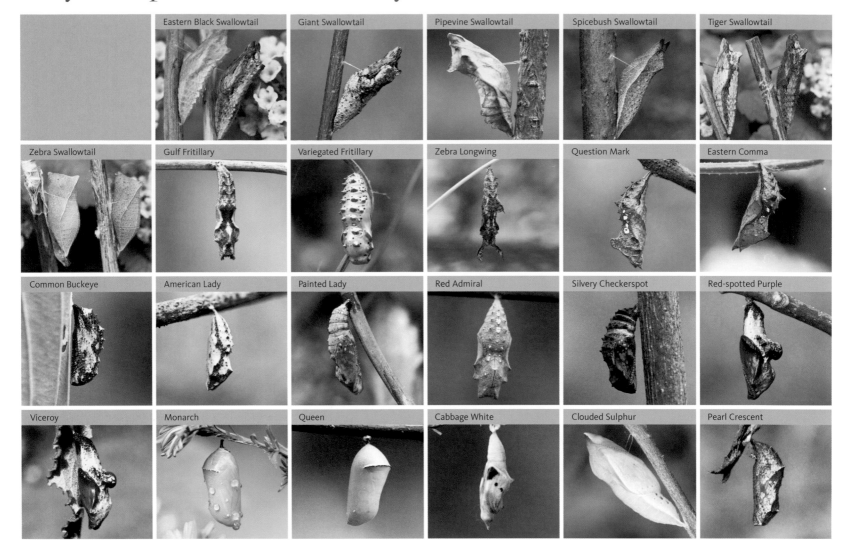

Eastern Black Swallowtail	Giant Swallowtail	Pipevine Swallowtail	Spicebush Swallowtail	Tiger Swallowtail	
Zebra Swallowtail	Gulf Fritillary	Variegated Fritillary	Zebra Longwing	Question Mark	Eastern Comma
Common Buckeye	American Lady	Painted Lady	Red Admiral	Silvery Checkerspot	Red-spotted Purple
Viceroy	Monarch	Queen	Cabbage White	Clouded Sulphur	Pearl Crescent

Many Thanks

We hope you enjoy this book. We wrote it to encourage readers to appreciate and understand the lives and struggles of butterflies. As more people plant habitat gardens and stop using poisons in their yards, the conservation and protection of butterflies will improve, and we'll all be able to enjoy their grace and beauty for many generations to come.

We'd love to hear from you. You can reach us at the following e-mail addresses and please come visit us at our Web site.

Judy Burris: jlburris@insightbb.com
Wayne Richards: wrichards@insightbb.com
www.ButterflyNature.com

SPECIAL THANKS TO:

Mary Richards, who encouraged us to reach for the stars and make our dreams come true. Thank you for helping us every step of the way. We couldn't have done it without you, Mom. You are our motivation.

Steve Burris, the best husband a butterfly girl could ever hope for. You have patiently endured a backyard that looks like a wild jungle and an infinite amount of obsessive flower shopping. You are my strength.

Christina Richards, a very special gift. Words cannot describe just how blessed I am to have you as my wife. You've always supported me and given me reason to strive to be the best that I can be. Love always.

David Freeland, our favorite uncle. We are so glad that you always take such a keen interest in our work. Thanks for believing in us. You are our encouragement.

Eva Burris, always on the lookout for new butterfly stuff. Thanks so much for all of your help and ideas.

Eric Bertelsen, a good friend and a constant source of positive energy. Thanks for everything.

Tom and April Brewster, who nurtured our photographic work in its earliest stages. Thank you for giving us the inspiration to continue to develop (forgive the pun) our talents.

Elaine Caines, whose kindness and friendship meant the world to us during a difficult time.

Edith Smith and family, great butterfly friends. Thanks for all your help and encouragement.

Tamara Chasteen (Earthscapes, Inc.), for showing such enthusiasm and appreciation for our butterfly passion. You are our fan club leader.

Index

Page references in *italics* indicate photos.

A

abdomen, *7, 16, 17*
aestivation, 138
Agraulis vanillae (Gulf Fritillary), *2, 12,* 44–47
Alcea spp. (hollyhocks), *118*
American Lady (*Vanessa virginiensis*), 68–71
American Snout (*Libytheana carinenta*), *139*
Anethum graveolens (dill), *117*
annual, 126. *See also* specific host or nectar plant
Antennaria plantaginifolia (plantain-leaved pussytoes), *121*
Antirrhinum majus (snapdragon), *122*
Aristolochia macrophylla (pipevine), *120*
Artemisia stelleriana ('Silver Brocade' Artemesia), *116*
Asclepias spp. (milkweed), *119, 129*
Asimina triloba (pawpaw tree), *120*
aster (*Aster* spp.), *116*
Asterocampa celtis (Hackberry Emperor), *137*
Asterocampa clyton (Tawny Emperor), *137, 138*

B

Battus philenor (Pipevine Swallowtail), *3, 14, 15, 28–31,* 85
bloodflower, *129*
Boehmeria cylindrica (false nettle), *117*
branched spines, *7*
breeding range. *See* specific butterfly

broods, 19
butterfly
 contrasted with moth, 142
 day in the life of a, *17*
 drunken, 79
 emergence from chrysalis, 11–12
 feeders, 114
 habitat garden, 115
 kite family, 43
 migration, 95
 senses of, 13
 wings, 13–14
 See also skippers
butterfly bush (perennial woody shrub), *128*

C

Cabbage White (*Pieris rapae*), 100–103
camouflage, 6, 10, 66, *78,* 107
caterpillar, 5–7
 comparison guide, *147*
 growth, 5–6
 liquefaction in chrysalis, 9
 parts, 7
Cecropia moth, *7,* 142
Celastrina ladon neglecta (Summer Azure), *139*
Cercyonis pegala (Common Wood-Nymph), *140*
chemical receptors, 3
chemicals, 113
Chlosyne nycteis (Silvery Checkerspot), 80–83
chorion, 2–3
chrysalis, 8–11
 claspers, *16, 17*
 comparison guide, *148*

formation, 8–9
 sampling, *10*
 "zipper," *105*
Cleome spinosa (spider flowers), *123*
Clouded Sulphur (*Colias philodice*), *3,* 104-7
cocoon, 142
Colias philodice (Clouded Sulpher), *3,* 104–7
Common Buckeye (*Junonia coenia*), 64–67, *129*
Common Wood-Nymph (*Cercyonis pegala*), *140*
comparison guide
 eggs, *146*
 caterpillars, *147*
 chrysalises, *148*
complete metamorphosis, 2
coneflower (*Echinacea* spp.), 15, *116, 127*
cosmos (*Cosmos bipinnatus*), *132*

D

Danaus
 gilippus (Queen), 96–99
 plexippus (Monarch), 9, *11, 12, 17,* 92–95
Daucus carota (Queen Anne's lace), *121*
Dianthus barbatus (sweet william), *132*
diapause, 9, 21
diet, 75, 114
dill (*Anethum graveolens*), *117*

E

Eastern Comma (*Polygonia comma*), 60–63
Eastern Tailed Blue (*Everes comynas*), *139*
Echinacea spp. (coneflower), *116, 127*
eclosion, 9, *73*
egg
 comparison guide, *146*

"dud," *40, 56*
 laying, 2–4, 17
 shapes and textures, *4*
Egyptian starflower (*Pentas lanceolata*), *133*
elm tree (*Ulmus* spp.), *117*
Enodia anthedon (Northern Pearly-eye), *140*
Euptoieta claudia (Variegated Fritillary), 48–51
Eurytides marcellus (Zebra Swallowtail), *3, 12,* 40-43
Everes comyntas (Eastern Tailed Blue), *139*
eyespots. *See* false eyespots

F

false eyespots, 6, *7, 33, 66*
false nettle (*Boehmeria cylindrica*), *117*
fennel (*Foeniculum vulgare*), *118*
field notes. *See* specific butterfly
flower nectar, 114
Foeniculum vulgare (fennel), *118*
forewing, *102*
Fritillary
 Great Spangled (*Speyeria cybele*), *129, 136*
 Gulf (*Agraulis vanillae*), *2, 12,* 44–47
 Variegated (*Euptoieta claudia*), 48–51

G

garden. *See* host plants; nectar plants
generations, 19
Gray Hairstreak (*Strymon melinus*), *136*

H

Hackberry Emperor (*Asterocampa celtis*), *137*
hackberry trees, 137, 138
head-butt, 6
Helianthus spp. (sunflower), *131*

"dud," *40, 56*
Heliconius charitonius (Zebra Longwing), *7,* 52–55
hemolymph, 11
herbicides, 113
hibernation, 9, 89
hidden head, *7*
hilltopping, 16
hollyhocks (*Alcea* spp.), *118*
"hop merchant," *61,* 63
hop vines (*Humulus* spp.), *118*
host plant, 3, 115–25. *See also* specific butterfly
hummingbirds, *133*
Humulus spp. (hop vines), *118*

I

instars, 5
invertebrate predators, 6

J

Junonia coenia (Common Buckeye), 64–67, *129*
juvenile hormone, 9

K

kite family, 43

L

lantana (*Lantana camara*), *128*
larva, 5. *See also* caterpillar
lepidoptera, 142
Libytheana carinenta (American Snout), *139*
life cycle season. *See* specific butterfly
Limenitis archippus (Viceroy), 88–91
Limenitis arthemis astyana (Red-spotted Purple), *13,* 84–87
Lindera benzoin (spicebush), *122*
Liriodendron tulipifera (tulip poplar), *124*
Little Wood-Satyr (*Megisto cymela*), *137*

M

mating, 15–16, 17
meconium, 12
Megisto cymela (Little Wood-
 Satyr), *137*
metamorphosis, 2, 5, 9
Mexican sunflower (*Tithonia
 rotundifolia*), *130*
milkweed (*Asclepias* spp.), *119,
 129*
molting, 5
Monarch (*Danaus plexippus*), 9,
 11, 12, 17, 92–95
 See also Queen; Viceroy
"Monarch Watch," 95
moth, 142
Mourning Cloak (*Nymphalis
 antiopa*), 14, *138*
M. virginiana (sweet bay magno-
 lia), *123*

N

nectar plants, 114, *126–33*
 See also specific butterfly
Northern Pearly-eye (*Enodia
 anthedon*), *140*
Nymphalis antiopa (Mourning
 Cloak), 14, *138*

O

orange butterfly weed, *129*
"Orange Dog," 25
orange glory flower, *129*
osmeterium, 6
ovum, 2. *See also* egg

P

Painted Lady (*Vanessa cardui*),
 70, *72–75*
palps, 139
Papilio
 cresphontes (Giant Swallow-
 tail), 16, *24–27*
 glaucus (Tiger Swallowtail),
 36–39, 115, 123
 polyxenes (Eastern Black

Swallowtail), *7, 13, 20–23,
 114, 115, 142*
 troilus (Spicebush Swallow-
 tail), *7, 9, 32–35*
Parsley caterpillar, 23
passion vine (*Passiflora* spp.),
 119
patrolling, 16
pawpaw tree (*Asimina triloba*),
 120
Pearl Crescent (*Phyciodes
 tharos*), 82, 83, *108–11*
Pentas lanceolata (Egyptian
 starflower), *133*
perching, 16
perennial, 126. *See also* specific
 host or nectar plant
pesticides, 113
petunia (*Petunia hybrida*), *133*
pheromone, 2, 15, 17, 98
Phlox paniculata (tall garden
 phlox), *130*
Phyciodes tharos (Pearl Cres-
 cent), 82, 83, *108–11*
Pieris rapae (Cabbage White),
 100–103
pipevine (*Aristolochia macro-
 phylla*), *120*
Plantago lanceolata (plantain),
 120
plantain-leaved pussytoes
 (*Antennaria plantaginifolia*),
 121
plantain (*Plantago lanceolata*),
 120
Polygonia
 comma (Eastern Comma),
 60–63
 interrogationis (Question
 Mark), 14, *56–59, 128*
Polyphemus moth, *142*
predators, 5–6, 148
prickly ash (*Xanthoxylum
 americanum*), *121*
proboscis, *11, 12*
professional breeders, 75

prolegs, *7*
puddling, 16
pupa, 9
pupate, 8

Q

Queen Anne's lace (*Daucus
 carota*), *121*
Queen (*Danaus gilippus*), *96–99.*
 See also Monarch; Viceroy
Question Mark (*Polygonia inter-
 rogationis*), 14, *56–59, 128*

R

range maps, 19. *See also* specific
 butterfly
Red Admiral (*Vanessa atalanta*),
 17, *76–79*
Red-spotted Purple (*Limenitis
 arthemis astyanax*), 13, *84–87*
rue (*Ruta graveolens*), *122*

S

saddle, *20*
Salix spp. (willow), *125*
salt, 16, 114
scales, 14, 26, *34*
scent glands, *94, 98*
shedding skin. *See* molting
silk, 8, *33, 142. See also* spinneret
'Silver Brocade' Artemesia
 (*Artemisia stelleriana*), *116*
Silvery Checkerspot (*Chlosyne
 nycteis*), *11, 80–83*
skippers, *141*
snapdragon (*Antirrhinum
 majus*), *122*
Speyeria cybele (Great Spangled
 Fritillary), *129, 136*
spicebush (*Lindera benzoin*),
 122
spikes, *20, 45*
spinneret, 8
spiracles, *7*

Strymon melinus (Gray Hair-
 streak), *136*
Summer Azure (*Celastrina ladon
 neglecta*), *139*
summertime butterflies, 12, 15
sunflower (*Helianthus* spp.),
 131
Swallowtail
 Eastern Black (*Papilio polyx-
 enes*), *7, 13, 20–23, 114, 115,
 142*
 Giant (*Papilio cresphontes*), 16,
 24–27
 Green-clouded (*Papilio
 troilus*), *33*
 Pipevine (*Battus philenor*), *3,
 14, 15, 28–31, 85*
 Spicebush (*Papilio troilus*), *7,
 9, 32–35*
 Tiger (*Papilio glaucus*), *36–39,
 115, 123*
 Zebra (*Eurytides marcellus*), *3,
 12, 40–43*
sweet bay magnolia (*M. virgini-
 ana*), *123*
sweet william (*Dianthus barba-
 tus*), *132*

T

tall garden phlox (*Phlox panicu-
 lata*), *130*
tall verbena (*Verbena bonarien-
 sis*), *127*
Tawny Emperor (*Asterocampa
 clyton*), 137, *138*
Thistle Butterfly, 75
thorax, *7*
Tithonia rotundifolia (Mexican
 sunflower), *130*
tongue, *11, 12*
toxic glycosides, 92, 119
Trifolium repens (white clover),
 125
tubercles, *7*
tulip poplar (*Liriodendron tulip-
 ifera*), *124*

U

Ulmus spp. (elm tree), *117*
ultraviolet light range, 13, 14

V

Vanessa
 atalanta (Red Admiral), 17,
 76–79
 cardui (Painted Lady), 70, 72
 virginiensis (American Lady),
 68–71
Verbena bonariensis (tall ver-
 bena), *127*
vertebrate, 6
Viceroy (*Limenitis archippus*),
 88–91. See also Monarch;
 Queen
violets (*Viola* spp.), *124*

W

white clover (*Trifolium repens*),
 125
wild carrot. *See* Queen Anne's
 lace
willow (*Salix* spp.), *125*
wing
 forewing, *102*
 scales, 14
 scent glands, *94, 98*
 slap, 15
 ultraviolet reflective, *14, 15*
 wet, *11*

X

Xanthoxylum americanum
 (prickly ash), *121*

Z

Zebra Longwing (*Heliconius
 charitonius*), *7, 52–55*
zinnia (*Zinnia elegans*), *131*

Other Storey Titles You Will Enjoy

The Backyard Bird-Lover's Guide, by Jan Mahnken.
An information-packed reference to understanding
more than 135 species of birds.
320 pages. Paper. ISBN 978-0-88266-927-4.

Beekeeping, by Richard E. Bonney.
Vital information to learn how to install a colony,
manage a hive, take a crop of honey, and more.
192 pages. Paper. ISBN 978-0-88266-861-1.

***Drawn to Nature Through the Journals of
Clare Walker Leslie,*** by Clare Walker Leslie.
An invitation to readers to take a moment to slow
down and see nature with renewed appreciation.
176 pages. Paper with flaps. ISBN 978-1-58017-614-9.

The Family Butterfly Book, by Rick Mikula.
Projects, activities, and profiles to celebrate
40 favorite North American species.
176 pages. Paper. ISBN 978-1-58017-292-9.
Hardcover. ISBN 978-1-58017-335-3.

Hive Management, by Richard E. Bonney.
A seasonal guide of concise information
to a range of beekeeping tasks.
160 pages. Paper. ISBN 978-0-88266-637-2.

Keeping a Nature Journal,
by Clare Walker Leslie & Charles E. Roth.
Simple methods for capturing
the living beauty of each season.
224 pages. Paper with flaps. ISBN 978-1-58017-493-0.

Nature's Art Box, by Laura C. Martin.
Cool projects for crafty kids
to make with natural materials.
224 pages. Paper. ISBN 978-1-58017-490-9.

These and other books from Storey Publishing are available
wherever quality books are sold or by calling 1-800-441-5700.
Visit us at *www.storey.com.*